art incorporated

the story of contemporary art

Julian Stallabrass is senior lecturer in art history at the Courtauld Institute of Art. He is the author of Internet Art: The Online Clash Between Culture and Commerce, Tate Publishing, London 2003; Paris Pictured, Royal Academy of Arts, London 2002; High Art Lite: British Art in the 1990s, Verso, London 1999, and Gargantua: Manufactured Mass Culture, Verso, London 1996; he also writes art criticism for publications including Tate, Art Monthly, the New Statesman, and the Evening Standard.

art incorporated

the story of contemporary art

JULIAN STALLABRASS

OXFORD UNIVERSITY PRESS

Great Clarendon Street, Oxford 0x2 6DP

Oxford University Press is a department of the University of Oxford. It furthers the University's objective of excellence in research, scholarship, and education by publishing worldwide in

Oxford New York

Auckland Bangkok Buenos Aires Cape Town Chennai Dar es Salaam Delhi Hong Kong Istanbul Karachi Kolkata Kuala Lumpur Madrid Melbourne Mexico City Mumbai Nairobi São Paulo Shanghai Taipei Tokyo Toronto

Oxford is a registered trade mark of Oxford University Press in the UK and in certain other countries

Published in the United States by Oxford University Press Inc., New York

© Julian Stallabrass 2004

The moral rights of the author have been asserted Database right Oxford University Press (maker)

First published 2004

All rights reserved. No part of this publication may be reproduced, stored in a retrieval system, or transmitted, in any form or by any means, without the prior permission in writing of Oxford University Press, or as expressly permitted by law, or under terms agreed with the appropriate reprographics rights organization. Enquiries concerning reproduction outside the scope of the above should be sent to the Rights Department, Oxford University Press, at the address above

You must not circulate this book in any other binding or cover and you must impose this same condition on any acquirer

British Library Cataloguing in Publication Data
Data available

Library of Congress Cataloging in Publication Data

Stallabrass, Julian.

Art incorporated : the story of contemporary art / Julian Stallabrass.

p. cm.

Includes bibliographical references.

1. Art Modern—20th century—Economic aspects. 2. Art, Modern—21st century—Economic aspects. 3. Freedom and art 4. Art and society. I. Title.

N6490.S728 2004 2004054785 709'.04'9-dc22 ISBN 0-19-280165-1

1 3 5 7 9 10 8 6 4 2

Printed in Great Britain by Biddles Ltd., King's Lynn

To Peter and Audrey

Contents

Lis	st of Illustrations	viii
Ad	cknowledgements	X
Α	zone of freedom?	1
2	New world order	29
3	Consuming culture	73
4	Uses and prices of art	100
5	The rules of art now	150
6	Contradictions	176
References and further reading		203
In	dex	217
Pi	cture acknowledgements	227

List of Illustrations

Black and White	
1. Mel Chin: Night Rap.	18
2. Kara Walker: Camptown Ladies.	22
3. Santiago Sierra: 160 cm line tattooed on 4 people.	44
4. Boris Mikhailov: At Dusk series.	47
5. Sergei Bugaev Afrika: MIR, Made in the Twentieth Century.	48
6. José Angel Toirac: Obsession, from the series 'Tiempos Nuevos'.	61
7. Xu Bing: A Book from the Sky.	65
8. Kcho: Speaking of the Obvious was Never a Pleasure for Us.	69
9. Takashi Murakami: Hiropon.	74
10. Thomas Ruff: h.e.k.04.	97
11. Francis Alÿs: Zocalo.	110
12. Liam Gillick: Renovation Proposal for Rooseum, Malmo.	120
13. Damien Hirst: Absolut Hirst.	133
14. Tobias Rehberger: Seven Ends of the World.	153
15. Paul Pfeiffer: The Long Count (Rumble in the Jungle).	156
16. Paola Pivi: Untitled (Aeroplane).	157
17. Gabriel Orozco: <i>La DS</i> .	159
18. Gavin Turk: Che Guevara.	180
19. Eduardo Kac: Alba, the Fluorescent Rabbit.	185
20. etoy. CORPORATION, TOYWAR site.	193

198

21. Allan Sekula: Waiting for Tear Gas.

Acknowledgements

While this book takes a position against much of the literature written on contemporary art, that writing has nonetheless formed it, and I would like to express my appreciation to all those who appear in the references section. I would urge readers to use this account as a staging post to go on to find more detailed analyses of subjects that can only be dealt with summarily here.

I have benefited greatly from conversations with many artists, academics, critics, and curators, and particularly from colleagues and students at the Courtauld Institute of Art. Many thanks also to Sarah James and Hyla Robiscek, who helped with my research.

Parts of this book have been previously published in the following places, though all these passages have been substantially altered for their appearance here:

'Shop until You Stop', in Schirn Kunstalle Frankfurt/Tate Liverpool, in *Shopping: A Century of Art and Consumer Culture*, ed. Christoph Grunenberg/Max Hollein, Hatje Cantz Publishers, Ostfildern-Ruit 2002

'Free Trade/Free Art', in Neil Cummings/Marysia Lewandowska, Free Trade, Manchester Art Gallery, Manchester 2003.

'Literally No Place by Liam Gillick', Bookworks website, June 2003: http://www.bookworks.org.uk/sharptalk/04/index.htm

Think of the use contemporary artists make of human bodies: of hair teased into patterns that form Chinese characters, or woven into a rug, or plucked from the artist's body to be inserted into a diminutive waxwork rendition of the corpse of the artist's father; blood let drip from self-inflicted wounds onto canvas, or made into a self-portrait bust; marks made on drawings by ejaculating over them—or over crucifixes; cosmetic surgery undergone as performance art; human ears grown in Petri dishes; a baby's corpse cooked and (apparently) eaten. Contemporary art seems to exist in a zone of freedom, set apart from the mundane and functional character of everyday life, and from its rules and conventions. In that zone there flourishes a strange mix of carnival novelty, barbaric transgression of morals, and offences against many systems of belief, alongside quieter contemplation and intellectual play. Discussion of contemporary art, ranging from specialist journal to tabloid column, encompasses respectful exegesis, complex philosophical diversions, fawning publicity, and finally denunciation, ridicule, and dismissal. Yet this familiar scene—how old and established is art's rule-breaking, and how routine are the accompanying recommendations and condemnations—masks significant recent change.

Some of this change has been driven by art's internal concerns, some is a response to broader economic and political

transformation. At first sight there seems to be no system against which it is currently more differentiated than the global neoliberal economy, founded on the ideal if not the practice of free trade. The economy functions strictly and instrumentally according to iron conventions, imposed unequally on nations by the great transnational economic bodies; it establishes hierarchies of wealth and power; it enforces on the vast majority of the world's inhabitants a timetabled and regulated working life, while consoling them with visions of cinematic lives given meaning through adventure and coherent narrative (in which heroes make their lives free precisely by breaking the rules), and with plaintive songs of rebellion or love. This is the nerve pressed on by Jonathan Richman's deceptively saccharine song, *Government Center*. Here are some of the lyrics:

We gotta rock at the Government Center to make the secretaries feel better when they put the stamps on the letter

The song ends with the dinging of a typewriter bell. It tells its listeners what pop songs are (mostly) for.

Art appears to stand outside this realm of rigid instrumentality, bureaucratized life, and its complementary mass culture. That it can do so is due to art's peculiar economy, based on the

manufacture of unique or rare artefacts, and its spurning of mechanical reproduction. Artists and dealers even artificially constrain the production of works made in reproducible media, making limited-edition books, photographs, videos, or CDs. This small world—which when seen from the inside appears autonomous, a micro-economy governed by the actions of a few important collectors, dealers, critics, and curators—produces art's freedom from the market for mass culture. To state the obvious, Bill Viola's videos are not play-tested against target audiences in the Midwest, nor are producers forced on art bands like Owada to ensure that their sound will play inoffensively in shops or appeal to a core market of 11-year-old girls. So this cultural enclave is protected from vulgar commercial pressures, permitting free play with materials and symbols, along with the standardized breaking of convention and taboo.

The freedom of art is more than an ideal. If, despite the small chance of success, the profession of artist is so popular, it is because it offers the prospect of a labour that is apparently free of narrow specialization, allowing the artist, like heroes in the movies, to endow work and life with their own meanings. Equally for the viewers of art, there is a corresponding freedom in appreciating the purposeless play of ideas and forms, not in slavishly attempting to divine artists' intentions, but in allowing

the work to elicit thoughts and sensations that connect with their own experiences. The wealthy buy themselves participation in this free zone through ownership and patronage, and they are buying something genuinely valuable; the state ensures that a wider public can inhale at least for a while the scent of freedom that works of art emit.

Yet there are reasons to wonder whether free trade and free art are as antithetical as they seem. Firstly, the economy of art closely reflects the economy of finance capital. In a recent analysis of the meaning of cultural dominance, Donald Sassoon explored patterns of import and export of novels, opera, and film in the nineteenth and twentieth centuries. Culturally dominant states have abundant local production that meets the demands of their home markets, importing little and successfully exporting much. In the nineteenth century, France and Britain were dominant in the production of literature. Currently, for massmarket culture, it is clear that the US is by far the dominant state, exporting its products globally while importing very little. As Sassoon points out, this does not mean that everyone consumes American culture, just that most of the culture that circulates across national boundaries is American.

Sassoon rules fine art out of his account on the sensible grounds that it has no mass market. It is hard to read trade

figures for signs of cultural dominance in a system that is thoroughly cosmopolitan, so that you may have a German collector buying through a British dealer the work of a Chinese artist resident in the US. We can, however, get an idea of the volume of trade in each nation, and, given the high volume of international trade in the art market, this does give an indication of global hegemony. Here there are striking parallels with the distribution of financial power. It is hardly surprising that the US is dominant, accounting for a little less than a half of all global art sales: Europe accounts for much of the rest, with the UK taking as its share around a half of that. France is a major source for art dealing, while Italy and Germany also have significant markets. Art prices and the volume of art sales tend to match the stock markets closely, and it is no accident that the world's major financial centres are also the principal centres for the sale of art. To raise this parallel is to see art not only as a zone of purposeless free play but as a minor speculative market in which art works are used for a variety of instrumental purposes, including investment, tax avoidance, and money laundering.

Secondly, and to banish such crude economic considerations from the minds of its viewers, contemporary art must continually display the signs of its freedom and distinction from the mass, by marking off its productions from those vulgarized by mass

production and mass appeal. It can make a virtue of obscurity or even boredom to the point that these become conventions in themselves. Its lack of sentimentality is a negative image of the sweet fantasies and happy endings peddled in pop songs, cinema, and television. In its dark explorations of the human psyche, of which the worst is generally assumed, it appears to hold out no consolation. Yet, naturally, all of this ends up being somewhat consoling, for above all the negativity quite another message emerges: that such a zone of freedom, and free critique, can be nurtured by the instrumental system of capitalism.

Thirdly, and most dangerously for the ideal of unpolluted cultural freedom, it is possible to see free trade and free art not as opposing terms but rather as forming respectively a dominant system and its supplement. The supplement may appear to be an inessential extra but (in Jacques Derrida's celebrated analysis) nevertheless, like the afterword to a book or footnotes to an essay, has a role in its completion and shares its fundamental character. According to this schema, free art has a disavowed affinity with free trade, and the supplementary minor practice is in fact important to the operation of the major one. So the tireless shuffling and combining of tokens in contemporary art in its quest for novelty and provocation (to take some recent examples, sharks and vitrines, paint and dung, boats and

modernist sculpture, oval billiard tables) closely reflects the arresting combinations of elements in advertising, and the two feed off each other incessantly. As in the parade of products in mass culture, forms and signs are mixed and matched, as if every element of the culture was an exchangeable token, as tradable as a dollar. Furthermore, the daring novelty of free art—with its continual breaking with conventions—is only a pale rendition of the continual evaporation of certainties produced by capital itself, which tears up all resistance to the unrestricted flow across the globe of funds, data, products, and finally the bodies of millions of migrants. As Marx put it a century-and-a-half ago, in a passage of striking contemporary force:

The bourgeoisie, by the rapid improvement of all instruments of production, by the immensely facilitated means of communication, draws all, even the most barbarian, nations into civilisation. The cheap prices of its commodities are the heavy artillery with which it batters down all Chinese walls, with which it forces the barbarians' intensely obstinate hatred of foreigners to capitulate. It compels all nations, on pain of extinction, to adopt the bourgeois mode of production; it compels them to introduce what it calls civilisation into their midst ... In one word, it creates a world after its own image (pp. 39–40).

It is not merely national barriers that are demolished. Continual

innovation in industry and culture dissolves old social structures, traditions, and attachments, so that in Marx's famous phrase, 'All that is solid melts into air ...'

We shall see that there are many artists who in differing degrees critically examine the affinity between contemporary art and capital. Yet in the general run of art-world statements particularly in those destined for the public rather than specialists—that affinity is largely invisible. Anyone who reads much about contemporary art will have frequently come across some version of the following mantra: this work of art/this artist's work/the art scene as a whole transcends rational understanding, pitching the viewer into a state of trembling uncertainty in which all normal categories have slipped away, opening a vertiginous window onto the infinite, some traumatic wound normally sutured by reason, or onto the void. According to this standard view, art works are only incidentally products that are made, purchased, and displayed, being centrally the airy vehicles of ideas and emotions, the sometimes stern, sometimes gentle taskmasters of self-realization.

In *The Rules of Art*, an exceptional analysis of French literature in the second half of the nineteenth century, Pierre Bourdieu traces the social conditions for the emergence of an autonomous art, free of the demands of religion, private patrons, and the state,

and left to its own concerns. He notes the survival of this belief—that art is inexplicable—born at that time, into the present:

I would simply ask why so many critics, so many writers, so many philosophers take such satisfaction in professing that the experience of a work of art is ineffable, that it escapes by definition all rational understanding; why are they so eager to concede without a struggle the defeat of knowledge; and where does their irrepressible need to belittle rational understanding come from, this rage to affirm the irreducibility of the work of art, or, to use a more suitable word, its transcendence (p. xiv).

Today art is supposed to have passed into a different epoch, far removed from the first flush of avant-garde activity in the work of Flaubert and Courbet, and its evolving devotion to art for art's sake. Beginning in the mid-1970s, and with increasing force, postmodernism was meant to have swept such concerns aside, challenging the category of high art itself, or at least delighting in its pollution by myriad cultural forms. So we start with a curiosity: that in the visual arts today those old notions of art's ineffability, touched more with mysticism than analysis, still thrive.

This continued insistence on the unknowability of art is strange, particularly since it has been accompanied recently by some transparently instrumental art practices. Since we cannot know what we cannot know, this mantra about the

impenetrability of the realm of art is evidently nothing but propaganda. The uses to which art is put, and the identity of those who use it, are often far from mysterious. Since the fall of Eastern European Communism and the emergence of capitalism as a truly global system, these uses have become both more advanced and more evident.

Beyond the cold war

The global events of 1989 and after—the reunification of Germany, the fragmentation of the Soviet Union, the rise of global trade agreements, the consolidation of trading blocs, and the transformation of China into a partially capitalist economy—changed the character of the art world profoundly. Ever since the capital of the arts switched from Paris to New York following the Second World War, the art world had, after all, been structured on the cold war division of East and West. The state-supported high art of each was a negative image of the other: if the art of the East had to conform to and represent a specific ideology and have a particular social use, then the art of the West must be apparently free of any such direction, and attain perfect uselessness. If the art of the East celebrated the achievements of humanity, and particularly of socialist Man, then the art of the West must focus on humanity's limits, failures, and cruelties (all

the while holding out the hope that art itself, in its very excavation of these troubles, may be an achievement in itself). With the fading of this antagonism (slowly under glasnost and then swiftly as the regimes of the East imploded), and with the much-trumpeted triumph of capitalism (the establishment of a 'new world order' in which the US was the only superpower), the art world swiftly reconfigured itself. As we shall see, a rash of art events peppered the globe, while artists of many nations, ethnicities, and cultures long ignored in the West were borne to critical and commercial success.

The shift was prepared for by postmodern critique which, in a complex series of theoretical moves, affirmed what the market had slowly sanctioned, unveiling the white male 'genius' skulking behind the universalist façade of high culture. Feminists challenged the male dominance of the art world, doing much to reformulate the very standards of judgement that has assured women's exclusion. The action of ethnic others took longer, and in the US, as we shall see, was attended by furious controversy.

The rise of the prominent multicultural show exactly coincides with the end of the cold war, with two shows, planned in the years of glasnost, breaking the institutional white monopoly in London and Paris: the Pompidou's *Magiciens de la Terre*, and the Hayward Gallery's *The Other Story*, both of 1989. Each was

controversial and, as first forays into this area, necessarily partial. Magiciens de la Terre, in particular, was criticized for exoticizing Third World artists, an attitude expressed in its very title. Nevertheless it was the first major exhibition in a metropolitan art-world centre to show contemporary First World and Third World art together. Rasheed Araeen fought against the indifference and condescension of the British art elite to produce The Other Story, which for the first time showed black and Asian British artists in a prominent public space. These exhibitions achieved a new visibility for contemporary artists of colour. And both—despite the fears of Araeen, who after years of marginalization rightly worried that his show might be no more than an isolated 'curiosity' in the white-out—proved to be heralds of a system under which non-white artists would no longer need complain of invisibility, and had to start worrying instead about the type of attention they were receiving.

Following the end of the cold war the global consolidation of an unrestrained type of capitalism, dubbed 'neoliberalism', also coincided with this first flush of colour to the art world's cheeks. Under neoliberalism, the language of free trade is spoken but the global regulatory bodies (the World Bank, the IMF, and the WTO) enforce rules that protect industries and agriculture in wealthy nations while opening fragile economies to unregulated trade

(including the dumping of below-cost goods), privatization, and the dismantling of welfare provision. The general results across the globe are low wages, insecure employment, high unemployment, and the weakening of unions. This system, and its catastrophic consequences for the weakest nations, has recently been plotted by ex-World Bank economist, Joseph Stiglitz, who shows, for example, how the IMF and the World Bank produced or exacerbated crises in Russia, East Asia, and elsewhere with grave and frequently lethal results for their inhabitants. Yet, despite the wealth that flows to transnational corporations—and, as we shall see, thus to the art world—the greatest effect on art has not been on its economy but its rhetoric. A loud chorus of voices has been heard praising the demolition of cultural barriers that accompanies the supposed destruction of barriers to trade, and the glorious cultural mixing that results. In this the art world is hardly alone, for a wave of enthusiasm for globalization has swept through the discourses of economics and politics, along with the humanities, from academic conference to liberal newspaper. The logic of such talk has been analytically skewered by Justin Rosenberg, who has shown the incoherence that emerges from analyses that purport to use the abstract qualities of space and time as the prime movers in social theory, replacing the parameters of economic, political, and military power, with

results that are often vague or merely rhetorical. In the art world, the ferment of talk about globalization has been just as slack and ubiquitous.

While the art world has taken up the politically liberal aspect of this rhetoric, in particular recommending the benefits of cultural mixing or hybridity, the overall vision behind it—the dream of global capital—has been thoroughly and swiftly reflected there. Art discourse, institutions, and works have changed rapidly as a result. Throughout the 1990s biennials and other art events were founded across the globe, while cities built new museums of contemporary art, or expanded old ones. The activities of these museums became steadily more commercial as they internalized corporate models of activity, establishing alliances with business, bringing their products closer to commercial culture, and modelling themselves less on libraries than shops and theme parks. At the same time, contemporary art has moved into closer contact with selected elements of a mass. culture that has become so pervasive that this turn is sometimes confused with a new engagement with the 'real' or 'real life'. Art stars have long been celebrities, but now the art scene as a whole is treated much like fashion or pop, and even its minor players appear in the organs devoted to tracking the intersecting orbits of the celestial bodies. In particular, art and fashion have

increasingly been seen hand-in-hand, as the cult of youth that has enveloped culture as a whole has also swept through the art world

While this account will often take the period since 1989 as if it were a unitary whole so that we may more clearly examine the structure of the art world and its products, a number of important changes associated with globalization have transformed contemporary art. These are the linked issues of politicized art in the US, the economic cycle, and a transformation in the standard form of contemporary art display.

Culture wars

In the US, contemporary art, particularly photography and performance, was at the centre of a political battle over central government funding of the arts. It was sparked by works which could be read as obscene or blasphemous shown in subsidized venues. In 1989, in front of his fellow senators, Alphonse d'Amato tore up a reproduction of Andres Serrano's *Piss Christ*, a photograph of a mass-produced crucifix immersed in the artist's urine. In 1990, for exhibiting Robert Mapplethorpe's exhibition *The Perfect Moment*, Dennis Barrie, director of the Cincinnati Contemporary Arts Center, found himself in the dock on charges of violating obscenity laws. The show had included depictions, in

Mapplethorpe's highly aestheticized black-and-white photographs, of gay sex, sadomasochism, and the results of the artist's long quest for the perfect (black) dick. Barrie was acquitted, though the defence was reduced to arguing that the photographs were art, and not pornography, because they could be enjoyed formally. These works and others were used as the basis for a Republican attack on the National Endowment for the Arts, the federal source of arts funding in the US. The attack was partly successful, substantially reducing the already modest sum at the NEA's disposal and, despite intense political controversy, eventually cowing opposition and contributing towards producing a more quiescent scene. As Douglas Davis has pointed out in a fine and detailed account of the Clinton administration's record on the arts, their strategy in the face of continued conservative attacks was defensive and limited, and certainly did not extend to any explicit support for the visual arts. The result was further politically motivated cutting of the NEA budget.

Conservative anger was directed at depictions and performances that celebrated gay sexuality, or objected to government inaction over AIDS, or openly displayed black bodies and sexuality. While such works were openly reviled, with a rage that laid bare the racism and homophobia of much of the US political landscape, the attack was also extended to political

works as such, and particularly to the entire exploration of racism in art. In 1994, the Whitney's *Black Male* exhibition, curated by Thelma Golden, was the subject of particular controversy, due to its many depictions of naked black men in an explicitly political show that took on the white establishment's fear of and subjection of black men. One piece that tellingly condensed the concerns of the show was Mel Chin's *Night Rap*, a police nightstick, the side-handle of which was shaped into an erect penis. *Black Male* was objected to not only by white conservatives uncomfortable with the political resonance of the subject but by black activists and artists objecting to its concentration on the nude, and thus possible confirmation of the very attitudes it set out to criticize.

More generally there was both a great deal of explicitly political art prominently displayed in the US in the early 1990s and a strident reaction against it among even moderately conservative critics, such as Peter Schjeldahl and Robert Hughes, who made a concerted attempt to have such work ruled out of the category of 'art'. A few years later, such critics did succeed in establishing a vogue for 'beauty' in contemporary art, as we shall see. The far right's attacks, by contrast, ultimately failed to alter the contemporary art scene significantly. Few could take seriously what was recommended in its place, namely a respectful and

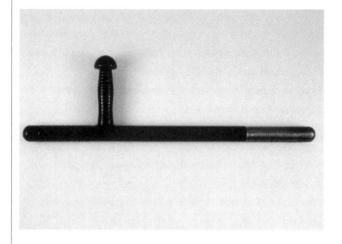

1 Mel Chin's Night Rap.

patriotic art that stepped straight out of the McCarthy era. But there was also a fundamental contradiction in their position: the cultural manifestations they objected to so vehemently were produced by the very economic forces that they were committed to defending.

Yet how did politicized art, long made by activists struggling against the mainstream, but little seen, come to such prominence? In part it was a reaction against the market-friendly art of the 1980s which had been so suddenly beached and stranded by the recession. In part, it was in anticipation of a liberal turn in politics, for many in the art world backed Clinton in 1992, and some were even involved in fund-raising for his campaign. If these expectations were disappointed in the long run, at first Clinton's canniness in handling cultural signs that suggested nascent change gave many heart. More important than either was a reconfiguration of US art in the face of the newly globalized art world. If the establishment of New York as the centre of the art world following the Second World War had meant a shift in the focus of American art from local and national concerns to supposedly universal themes, then the new order required the abandonment of universality in favour of an exploration of diversity, difference, and hybridity. The physical centre of the art world remained right where it was, as we shall

see, for as the world's most multicultural nation the US has this advantage under the new system to add to its economic and political might. Yet it could not exercise that advantage until its own prejudices and exclusions—barriers to trade—had been confronted. The 'Culture Wars' and the battle over political art that followed were a modernizing process. They were to be replayed in other nations where religion held a prominent place in politics and public life, with similar art scandals over abused religious symbols and explicit sexual scenes causing censorship and the sacking of curators in Poland and Greece.

If the prominence of this political art was comparatively brief, this was partly because it had served its purpose: art did diversify, and once it had adapted to its circumstances, could not go back. If it failed to fulfil its own wider ideals, this was because of its incomplete character, being disconnected from actual political processes. Benjamin Buchloh, in a mordant but compelling account of contemporary art, argues that the long trend in the US (and one may add elsewhere) for politics to move from the public to the private realms was reflected in an art that focused on artists' identities and the way these could be constructed through assemblages of conventional signs. These concerns were more comfortable to explore than the intractable issues of social class and indifferent political institutions. Or, making a related

point, Martha Rosler argues that while the US was marked by growing inequality of income, demands for cultural inclusion increased, resulting in

an art world version of multiculturalism (and where more appropriately situated than in the realm of culture?), necessary but sometimes painfully formulaic, which produces a shadow constellation of the identities of the wider society but without the income spread (p. 23).

The identities formed by money and class, and their integral links to other identities, were forgotten in this politics. So when the US economy revived, especially through the mid 1990s, a mutated market-friendly work once again came to the fore, in which identities became spectral associations, their blending and wafting this way and that being the subject of consumerist whim. One striking exemplar is the highly successful work of Kara Walker whose cut-out fantasy scenes of sex and violence down on the plantation generated much dispute. Identity at its most traumatic—the utter humiliation of slavery—is literally seen in silhouette as caricatured figures act out the gross acts of subjugation, rendered in a sweet, fairytale manner. As Coco Fusco points out, there is no clear moral frame of reference here, and the work does not document or preach but appeals to suppressed fantasy and desire. The question is, whose desires?

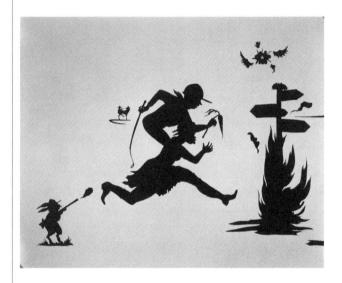

2 Kara Walker, Camptown Ladies.

Some black commentators, notably Betye Saar, were deeply uncomfortable with Walker's sudden and dramatic success in the mainstream art institutions, seeing the work as amusing a white audience with a dangerous confirmation of their own prejudices.

Since the art world is bound to the economy as tightly as Ahab to the white whale, another way of looking at that same relationship is through the economic cycle. The period under discussion here—from 1989 to the present day (I write as US troops squat in Baghdad, confirming a new and decidedly antiglobalist imperial order)—is bounded on either side by recession. The first was the spectacular crash of 1989 that put paid to the bloated artistic giants of the 1980s glut, shattering art-world selfimportance and confidence, and in the longer term producing ruder and more populist work, alongside politically committed art. The bubble that burst was pricked by the sudden withdrawal of Japanese buying from the market, partly caused by wider economic problems, but also by the scandalous revelation that much art-buying in Japan had been undertaken as a way of evading tax on real-estate profits, to the benefit of organized crime and corrupt politicians, with the side-effect of artificially inflating prices.

The second global recession was a slower-burning affair for those in the West, caused by the failure of the high-tech sector,

and followed by general falls in the stock market, scandals over financial corruption, and war. Between these two recessions, economic revival was uncertain, except in the most outrightly neoliberal economies of the West where it was buoyed on the high-tech and dot.com bubble. In those nations, glut produced (as we shall see, predictably) a reaction against art that engaged with theory and politics, in favour of work which set out to prettify, awe, entertain, and be sold.

The other signal change in 1990s art was the rise of 'installation art'. This is a complex and contested term. Some see it as an art that firmly resists buying and selling, being by definition ephemeral and difficult or impossible to move around. So, as Julie H. Reiss has it, installation—born in the 1960s—has revived from its long slumber through the commercially driven years of the early 1980s. In its first life (then known as 'environment' art) it had been shown in newly founded 'alternative' and often artist-run spaces. Installation's renewed popularity coincided with the recession of 1989, but in its reawakened form it established itself at the heart of the art world, in museums; that is to say (as Roberta Smith puts it) it appeared in 'the very places it was supposed to render obsolete'. The change in name from 'environment' to 'installation' is significant, for exhibitions are installed. Installation no longer necessarily resists

commodification, since it is now often moved and paid for. Even when this is not the case, it is regularly used by artists and dealers as a loss-leader for more marketable products.

Installation is not medium-specific or itself a medium. It encompasses video and increasingly older media like painting, and may be seen as a spatial art in which all media—even elements of performance—are subsumed. Nevertheless, its rise has been accompanied by a relative decline in the traditional media of painting and sculpture. Yet the art world is layered vertically and heterogeneous horizontally, comprising many overlapping spheres of association and commerce. Painting, whether or not it occupies the limelight of art discourse, is still the most saleable form of art, and continues to be made and sold to individuals and corporations more or less successfully depending on the state of the economy. Much the same could be said of drawing, printmaking, artists' books and a host of other practices. The focus here, however, is on what takes the limelight, and what circulates internationally in the heights of the cosmopolitan art world.

In this context, installation has two marked advantages. The first is in the continuing competition with mass culture—how to persuade an audience to travel to a museum or other site rather than watch television, go to the movies, a gig or a football match,

or shopping. There has been an intensification of competition here, a vying for spectacle, with television—to take a signal example—transforming itself with large, wide screens, high definition, and DVD recording. We have seen that art sets itself off from mass culture by its handling of content. Aside from that, what the reproducible media cannot yet simulate is the feeling of a body moving through a particular space surrounded by huge video projections or work that has weight, fragrance, vibration, or temperature. So installation, which allows a space to be inhabited rather than merely presenting a work of art to be looked at, comes to the fore. In this battle over spectacular display, artists and museums have avidly seized on new technology, especially digital video and video projection.

The second advantage is that the exclusive commissioning of a work for a particular site is a way of ensuring that viewers have to go there, and collections of such works by important artists clustered in a biennale are powerful magnets for art-world attention. In this way, installation and site-specificity are linked to the globalization of the art world, and an art used for regional or urban development. Since this is now the regular strategy, being there—not only in Venice, Basle, and Madrid but now in São Paolo, Dakar, and Shanghai—has become another way to confirm social distinction on the viewer (as only slight exposure to art-

world chatter, so often fluttering about the latest exotic jamboree, will confirm).

In later chapters the links between these various elements of art since 1989 will be explored: the US Culture Wars may be seen as a domestic prelude to the wider issues of global hybridity, and were constituted by the same disposition of forces: on one side, liberal consumerism committed to the demolition of restraints on commerce in the broadest sense; on the other the local forces. of tradition, religion, and moral deportment. Installation (again, broadly taken) is associated with spectacle and competition with the mass media. Contemporary installation is expensive and is generally reliant on private sponsorship and public funding. It is thus tied to corporate involvement in the arts and the commercialization of the museum, in a way that directly cuts against its origins in do-it-yourself artists' projects; this in turn is linked to the connection between globalization and privatization (of which the privatization of the art world is just a small part) which pushes museums and galleries into ever more spectacular display. Similarly, the symbiosis with elite elements of mass culture, and the urge to engage with 'real life' (which is to say, consumer culture and the concerns of the mass media) are part of the same impetus.

Lest this account seem too neatly parcelled up, I hope it will

become clear that there are considerable strains and contradictions between these elements. In the chapters that follow, on globalization, the relation with mass culture, the cost and uses of art, the characteristics of art and of writing about it, these contradictions will be explored. Finally, and to state the obvious, a book of this length can only be an introduction, and has to exclude vastly more than it can include. The inclusion of artists and works should not be seen as implying any judgement of quality but is instead an indication of their centrality to the book's core concerns: the regulation and incorporation of art in the new world order.

Doris Salcedo is a Colombian artist who makes sculptures out of furniture that once belonged to people who have 'disappeared' in her country's long civil war. In this bitter struggle, both sides guerrillas and government—fund the war by drug-dealing, while the Colombian army, despite their long record of human rights abuses, is lavishly supported by the US. Paramilitaries closely allied with government forces abduct and murder people with impunity. In some of Salcedo's works, one piece of furniture is carefully placed inside another in a coupling. In others, what looks at first sight like the grain of wood turns out to be human hair. These assemblages are sealed up with cement, which also sometimes partially submerges a door or an upturned table. In looking at these pieces there is a feeling of extremely slow submersion or erosion, a graph of the action of memory, seared by violence into the mind, sealed up by silence and censorship, returning unwanted in dreams and involuntary thoughts; and equally painfully losing its precise definition as time passes, and new memories, and memories of memories, are laid over old.

Giles Gilbert Scott's Anglican Cathedral in Liverpool is a vast, bare Gothic building, conventional in grandeur and architectural layout but built through the course of the last century. To walk within it is to feel a strong sense of the uncanny. Where, visitors think, are the trappings of historical memory, the signs of their

erasure and erosion, the familiar clutter of centuries? It is rather that an ancient cathedral was newly minted, and left naked.

The first Liverpool Biennial of Contemporary Art, held in 1999, included an international component, *Trace*, curated by Anthony Bond, which placed pieces of contemporary art in various locations around the city. Salcedo's work appeared in the Anglican Cathedral What did this combination amount to? The seventy years of the cathedral's construction spanned two world wars, the rise and dissolution of political radicalism in Britain, deindustrialization, and the sweeping secularization of that society, so that the completed product was born outsized into a city drained of work, population, and faith. Salcedo's art, a meticulous and highly laborious attempt to honour memory, is a visual counterpart to Eduardo Galeano's extraordinary works of the recovery of collective, political memory in the face of the violent suppression of protest in word or deed throughout much of Latin America. More specifically, as Charles Merewether points out, her pieces speak against the freezing and suppression of memory that disappearance is designed to produce, for the mourners lack a body, a grave, and even the certainty that their loved one is dead. Visually, Salcedo's works sat well in the vast, bare spaces of the cathedral, her cabinets like mutated confessionals or oversized coffins. Site and work in such

juxtaposition are meant to combine to enrich each other, productively bringing cultures together, provoking thought, and granting insight to other histories and cultures. Although it is fitting to place gravestones in a cathedral, here the combination seemed antithetical, since Salcedo's ritual forms of memory worked against the ghost of Anglicanism, in a building that had been erected unchanged, and as if nothing had changed.

Trace was a typical theme for a biennale, since it could be stretched to include just about everything and thus meant very nearly nothing. The Liverpool Biennial is an umbrella event, which takes in older annual shows, including the New Contemporaries exhibition and the John Moores painting competition. Liverpool is highly suited for such an event: a city of docks, its once great wealth based on trade, including slavery, serving as an appropriate setting for histories of trade and globalization. Its now down-at-heel urban fabric has plenty of large vacant spaces for displaying art, and its run-down areas, snags for romantic imaginings, are ripe for gentrification. All this set up some productive and provocative opportunities for the display of art, notably Ernesto Neto's tumescent spice sacs that hung in the Tate, filling the air with perfume in what had once been a warehouse for these very goods. Similarly, Vik Muniz in his Aftermath series makes poignant and complex work about the

street children of his native city, São Paulo (see Plate 2). Giving them reproductions of paintings by Van Dyck, El Greco, and Velázquez, and getting them to act out the poses, he photographs them. The photos are then used as the basis for elaborate images made up of refuse and confetti, the kind left on the street after Carnival has passed, out of which sketchy images of the children appear, spectrally traced in sugar. These are then photographed and the large-scale photos displayed in the gallery. Seen at the Tate, which bears the name of a sugar baron, the work gained another dimension.

The foreword to the *Trace* catalogue claims that the biennial reflects the city's 'current urban renaissance', though in 1999, this was more an aspiration than a statement of fact. The scattering of art exhibits around the city, wrote Bond, 'ensures that visitors will discover the rich character of Liverpool as they experience the art'. So the link to tourism was made explicit, and indeed the experience of the biennial for visitors to the city was that of moving from place to place as a tourist, constantly referring to maps. There was a bewildering concatenation of works and places, and a lack of contextual material for both; given that the event's principles were vague at best, the experience became primarily an aesthetic exercise in seeing work against an architectural setting, except for exceptionally well-informed art-

world insiders (for whom, perhaps, it was primarily made).

The catalogue lists the biennial's sponsors and contributing organizations, which included business, local academic institutions and art boards, national arts councils, and state bodies promoting culture abroad, such as the Goethe Institute. This mix was telling of the kind of alliances that a biennale produces: businesses, large and small, wanting to boost their brand recognition; nations pushing their cultural products; regional bodies hoping for regeneration; and universities wanting to raise their research ratings.

The Liverpool Biennial is merely one example of an increasingly widespread phenomenon. While the art world has long been cosmopolitan, the end of the cold war, as we have seen, brought about a considerable retooling of its practices and habits. Just as business executives circled the earth in search of new markets, so a breed of nomadic global curators began to do the same, shuttling from one biennale or transnational art event to another, from São Paulo to Venice to Kwangju to Sydney to Kassel and Havana. Of those events in developing and Communist states, some were long-established (like the São Paulo Biennial, founded in 1951, though recently revamped and funded on a larger scale), while others were entirely new. Here are just some of the new arrivals along with their starting dates: Havana Biennial

(1984), Sharjah Biennial, United Arab Emirates (1993), Kwangju, South Korea (1995), Johannesburg Biennale (1995), Shanghai Biennale (founded 1996, opened to international artists in 2000), Mercosur Biennial held at Porto Alegre, Brazil (1997), DAK'ART, Senegal (1998), Busan Biennale, Korea (1998), Berlin Biennale (1998), Yokohama Triennale (2001), and Prague (2003). The general art-world view of this development is sanguine: the linear, singular, white, and masculine principles of modernism have finally fallen, to be replaced by a multiple, diverse, rainbowhued, fractally complex proliferation of practices and discourses. Rosa Martínez, one such international curator, replies to the question what makes a biennial?' that

The ideal biennial is a profoundly political and spiritual event. It contemplates the present with a desire to transform it. As Arthur Danto says, in a definition I love, a biennial 'is a glimpse of a transnational utopia'. (p. 39)

In each event, ideally, the point is to bring about an exchange of the blue-chip standards of globalized art—and to look at the biennale rosters is to see how many of the same names insistently recur—into productive contact with local artists and circumstances. Ideally again, this should in time produce a hybrid diversity of art forms produced by people of widely differing backgrounds and attachments, that will speak both globally and

locally, inhabiting and producing in-between spaces that undermine the homogeneous blocs—above all, the nation-state—on which power relies.

It is an ideal that has powerful theoretical backing—in particular from writing by Homi Bhabha and Stuart Hall, regularly aired at the art events and in their accompanying literature, and it has helped produce a rise to prominence of artists from nations that had previously achieved such success only in exceptional cases. These artists, from China, Cuba, Russia, South Africa, or Korea, for example, bring to the global art world new voices, perspectives, ideas, and styles. The intensity of Salcedo's work, which comes out of her collaboration with grieving relatives of the disappeared, is a world away from the second-hand, mediainspired fantasies of violence in, say, Damien Hirst or the Chapmans, and makes them look decidedly ridiculous. Such work has transformed the art scene and been at the forefront on the circuit of international shows. Third Text, a journal devoted to fostering and analysing Third World perspectives on art and culture, has had to shift its primary purpose from making such art and opinion visible to exploring the conditions of its remarkable success. Indeed, Jean Fisher has argued that the key problem is no longer invisibility but rather an excess visibility that comes about because cultural difference has become so readily marketable.

We can get some idea of the terms on which this success has taken place by looking in turn at the biennales, some contrasting cases of art made in various regions, and then at the function and effect of this new ferment of globalized art production and consumption.

The extraordinary proliferation of biennales is driven by the same forces that have caused new museums to spring up like mushrooms, and old ones to expand or rebuild. Governments are well aware that cities increasingly compete on a global scale against one another for investment, the location of company headquarters, and tourism. The most successful cities must secure, along with economic dynamism, a wide variety of cultural and sporting fixtures. The biennale is merely one arrow in any would-be global city's quiver—or, as often, in one that aspires to that status—drawing in a particular class of tourist (some of them extremely wealthy) and hopefully entertaining those residents who have the power to leave.

A statement by influential curator, Hou Hanrou, who has assembled a series of shows exploring rapidly growing and changing Asian cities, puts the art-world interest clearly:

These new global cities represent the erection of new economic, cultural, and even political powers which are bringing about a new world order

and new visions for the planet. What is the most important thing is that with their own specific legacies, these cities become new and original spaces in which new visions and understandings of Modernity, and new possibilities of 'Utopian/dystopian' imagination, can be elaborated and reinvented (p. 78).

Such shows are, then, a cultural elaboration of new economic and political powers. They can have other more specific, uses. One example would be the Istanbul Biennial, which is part of the Turkish government's effort to assure the European Union that the nation conforms closely enough to secular and neoliberal standards to warrant membership. Another, the Havana Biennial, serves to give the Cuban government a more lenient and culturally open-minded image by sanctioning dissent within this narrow and delimited frame.

The biennale has two further benefits that mark it out from a fair of new technology or an important football match. Firstly, despite all the academic nay-saying from critics and theorists, in the public and civic eye art retains a kudos that transcends ordinary culture and entertainment, and gestures towards the universal. As such, it performs the same function for a city—with all its crude jostling for position in the global market—as a Picasso above the fireplace does for a tobacco executive. Secondly, it not only embodies but actively propagandizes the virtues of globalization.

There are circumstances in which the general and specific uses of biennales come up against the ideals they are supposed to embody. The Johannesburg Biennale was established in 1995. not long after the first free elections were held in South Africa in 1994. The idea was to reconnect South Africa with the cultural world after years of boycott. For the first biennale a large and very diverse series of exhibitions was mounted in an attempt to portray Johannesburg as a fully formed global city. Local artists who would have presented a troubled view of the nation were generally excluded, and many thought that the biennale presented a dubiously positive picture of South African society. While the biennale included South African curators and consulted widely with the local art world, it was much criticized by locals for being an alien incursion into an otherwise deprived and divided region that was in no way ready for it. Thomas McEvilley, among others, was astonished to see that the event had apparently been boycotted by much of the black community, repulsed by the sycophantic courting of the international art world.

In 1998, the second biennale—curated by Okwui Enwezor and an international team on the theme *Trade Routes: History and Geography*—attempted to respond to the critique of the first, being a political show that dealt with issues of race, colonization,

What caused this failure? Jen Budney argues that the biennale was trying to appeal to a middle-class audience (either white or a tiny new black segment) which had little interest in the cultural ideals of the exhibition. That the biennale found it hard to attract a local audience is unsurprising, since many South African whites have maintained de facto segregation and are hardly receptive to a display of multicultural globalism, while the black elite have more immediate concerns; as for the rest of the population, the pact with the West which brought about the end of apartheid, purchased with a pledge to handle the economy in conformity with the usual global strictures and so condemn them to continued poverty, could not be celebrated without ambivalence.

Even with those events that do succeed, similar tensions are apparent. In Havana the biennial has been a great success in drawing in an art audience to its displays of Cuban and Third World art. While the city's general populace is far better educated than those in the South African shanty towns, it does not follow that they are any better served by their biennial, which seems to have been made primarily for foreigners. Numerous stories circulate of media works turned off after the opening, or of venues prematurely shut. Coco Fusco writes of the restructuring of Cuban art around foreign patronage at the Havana Biennial of 2000:

Planeloads of American and European curators arrived ... Under the watchful eye of Cuban cultural officials and the latest handful of American *cubanólogos* who serve as intermediaries, they were shepherded to select studios and exclusive cocktail parties, and escorted to the main exhibition, an event that was far too expensive for most Cubans to attend. There, for a few hours, numerous video projections and a few live events were activated strictly for foreign onlookers. When other visitors arrived in the days that followed they found few if any machines in operation (p. 156).

In his piece for the 2000 Havana Biennial, *Santiago Sierra Invites You for a Drink*, the artist made a barbed comment about the likely relations of power and exploitation between art-tourists and natives by paying prostitutes to hide in boxes that had been set up as benches for the party-goers.

Biennales tend to address the cosmopolitan art audience rather than the local population. Their structure was inherited from the model of the international art or trade show in which nations compete to push their most prominent cultural wares in the global market. While many biennales have moved away from the physical embodiment of this competition in national pavilions, the atmosphere of national rivalry sometimes remains. Furthermore, the curators of these shows, nomadic specialists, are creatures of the global art system. They do, of course, listen,

consult, and induct local voices, but their very *raison d'être* and the environment in which they move is global and hybrid. In a critical analysis of the role of the globe-trotting curator, Carol Becker writes:

Some who move through such an elite world of art, culture, writing, production and exhibition now seem to answer only to the art world. Even though the work seems to be socially motivated, the only real consequence of such critical effort is the degree to which the work is found acceptable, unacceptable or exceptional by the art world, measured by the reviews it receives—the quality of the paper trail it generates, and relatedly the sales it ultimately accomplishes (p. 27).

The filtering of local material through the art system ultimately produces homogeneity. This system—not just the curation but the interests of all the bodies, private and public, that make up the alliances around which biennales are formed—tends to produce an art that speaks to international concerns. More specifically, it reinforces neoliberal values, especially those of the mobility of labour and the linked virtues of multiculturalism.

One striking example was Alfredo Jarr's work, *One Million Finnish Passports*, shown at the international art festival ARS 95, at the Museum of Contemporary Art in Helsinki. Jarr made slightly altered copies of a million Finnish passports and arranged them

in an impressive block, reminiscent of minimalist constructions, behind a security screen. The passports represented for all those that would have been granted to migrants had the Finnish government permitted immigration at the rate of the rest of Europe. On the insistence of the Finnish immigration authorities, Jarr's piece was later destroyed.

This work was typical of globalized art production in many ways. It used both local material and the cosmopolitan language of contemporary art; it responded to and commented on local political issues. In doing so it took the side of the interests of global capital over that of one element of local concern, for the message of the work was that people's right to resettle must override any national determination, even one democratically arrived at, to protect homogeneity and social cohesion.

We will return to this issue, and to the homogenizing effect of the global art system, but in stressing first its variety, I want to take two pairs of contrasting cases: the different kinds of work produced by the shock of exposure to neoliberal economic forces, in Russia and Scandinavia; and then work from two nations that have retained Communist governments, China and Cuba.

Russia and Scandinavia

In the 1990s, both Russia and Scandinavia were newly exposed to

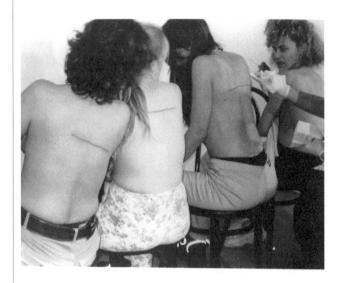

3 Santiago Sierra, 160cm Line Tattooed on 4 people.

humiliations and exposures). In *By the Ground* (1991) and *At Dusk* (1993) he simulates the look of photographs of the early twentieth century, depicting life on Ukrainian streets; he again focuses on the many street-dwellers, but also on those who may have homes but barely manage to subsist. Subject-matter as well as style evoke a pre-Revolutionary era. Here is an effective visual analogue to the feeling that many have in post-Soviet society of history and progress being thrown into reverse, as the capitalism that was supposed to transport them into the consumerist present instead produced a layering of time-frames, pushing the majority back to the deadly penury of Czarist times.

Sergei Bugaev Afrika represented Russia at the 1999 Venice Biennale with an installation called *Mir: Made in the XXth Century*. This highly ambitious multimedia piece made large statements about the Soviet era. I saw the piece in New York, where the floors and walls of the gallery had been covered in tin tiles that bore propaganda photographs of Soviet life, which again were printed to look antique. The metal buckled when walked over, while the photographs had the air of childish illustrations found on biscuit tins. In the centre of the room was a large metal globe encasing a video of a man tied to an electrical device, crying out and biting on a strap in pain. The film appeared to be found footage, but that can—of course—be faked; my immediate

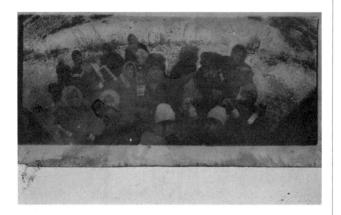

⁴ Boris Mikhailov, At Dusk series.

5 Sergei Bugaev Afrika, MIR: Made in the Twentieth Century.

response to the piece, seen in a commercial gallery, was to think that it was a performance. The video had in fact been copied from a documentary film of someone forced to undergo electroshock therapy, and what we, a polite crowd, booze in hand, were seeing at this launch was the spectacle of a mind's ruination. Afrika's piece sought to align psychological and social trauma, to reveal the painful and brutal repression that underlay the system that represented itself with such benevolence and heroism in its photography, and to throw those old and potentially nostalgic depictions against the destruction of memory.

To the accompaniment of further controversy, Afrika has gone on to make a work based on documentary film of the slaughter of a Russian patrol by Chechen rebels. These two examples are indicative of the premium that post-Soviet reality holds in the Western art world. It may be found in photography and film, with all the old postmodern lessons about representation dimly remembered, but even so taken as real. Or it may be acted out in expressive performance, as in Oleg Kulik's *Dog* in which the naked artist assaults his audience, trying to bite them, a humanturned-dog, in an apparently authentic acting out of Russian abjection and degradation.

The appeal of such work for Western audiences is clear

enough: an exotic brew of burgeoning capitalism (with its robber barons and swashbucklers or, otherwise put, large-scale swindlers and murderers) and of the sudden birth of a white European Third World; of the romance of a crumbling 'evil' Empire and a fallen enemy (entertaining for liberals and conservatives, alike); and of an ideology passed into history. Russianness, which now encompasses all this, plays best when overtly displayed.

What it is harder for Western audiences to grasp, perhaps, is how these works do not necessarily plot the exotic otherness of the Slavic soul, or even Soviet history, but refer instead to a capitalist present. Mikhailov's work is about nothing other than the effects of an unrestrained capitalism in which everything is for sale. Kulik's *Dog* is surely an update of Bulgakov's tale, *The Heart of a Dog*, in which a dog is surgically altered to take on human form and thrives, because of his base instincts, in Soviet society of the 1920s. Yet the society that Bulgakov dissected was in tactical retreat from an attempt to foment fully revolutionary communism and was temporarily using free-market measures to stimulate the economy; in the period of the 'New Economic Policy' a class of nouveaux-riches sprang up, flaunting their often dubiously acquired wealth. It was, in other words, a milder version of Russia today.

In contrast, in the 1990s Scandinavia's efficient social-

democratic economies were suddenly forced in a neoliberal direction through the deregulation of financial markets and the abandonment of foreign exchange controls. The process was made worse by the recession of the early 1990s, which forced Scandinavian governments to partially dismantle the social programmes for health and welfare their citizens had long taken for granted. Unemployment, an unwelcome novelty, rose as manufacturing industry collapsed. Mass immigration began to transform what had been enclosed and quite homogeneous societies.

In Scandinavia, as elsewhere, modernism and social democracy had been strongly associated. Just as social democracy had long survived the right-wing and neoliberal forces that affected much of the rest of the world from the late 1970s onwards, in the Scandinavian art world a clean, constructivist modernism also survived beyond its allotted span. The recession and its consequences led to a shift in the role of art from utilitarian design and the creation of utopian-constructivist projects to overt critique. Social democratic governments had financially supported the arts, making artists insiders, in a way that was hard to disavow, as many did elsewhere. This continued into neoliberal times, even as artists struck up antisocial poses. A collection of Scandinavian artists' writings—acidly entitled *We Are All Normal (and We Want Our Freedom)*— contains a passage that

puts the matter well:

'The artist seems to act as indicator for the degree of freedom in Scandinavian society, and as much as the artist refuses society—as the traditional role of the artist—the more he affirms it.' (p. 70)

That critique, which the new system requires, closely conforms to the liberal rhetoric that accompanies neoliberalism. Local or national resistances to that form of economy and society achieve little cultural expression in the global art world. The suspicion is that art may have played an (admittedly minor) role in propagandizing, but neoliberalism itself.

The collision of those well-protected societies with hard economic forces produced a bright and variegated shower of never-before-seen cultural particles. As a result, contemporary Scandinavian art came to global attention, along with its music and cinema. The consequences of the new situation were plainly seen in the exhibition *Organising Freedom: Nordic Art of the '90s* in 2000. As the exhibition's curator, David Elliott, states in the catalogue, these artists 'seem seriously pissed off' about something, and they have issues with (among other things) rational architecture, utopian dreams, idealism, and social engineering. Jakob Kolding uses constructivist forms in his collages, pitching old, radical visions of extreme disorientation (as

found in the Russian revolutionary avant-garde) against the politely regulated architecture and social planning that were its Scandinavian progeny. Kolding was brought up in one of Copenhagen's model suburbs in which everything was safely pedestrianized, and shops, schools, nurseries, and clinics were close to hand. This, we are meant to assume, is a terrible fate, and no doubt so it must be until these facilities are closed.

The universal modernist 'Man' of basic needs has splintered into the shards of competing interests and antagonistic identities. With this salutary disintegration there arises an examination of the diminished figure that remains, in Maria Friberg's photographs of businessmen's crotches or of a bald head breaking through the churning of creamy surf, or in Maria Hedlund's strange close-up photographs of checked shirts. Miriam Bäckström has photographed show interiors at the Ikea Corporate Museum, a series of cramped and sterile interiors. Ikea's mission is a modernist, egalitarian, and democratizing one: the rational, economic, and gradual improvement of domestic space. Bäckström, like many other contemporary Scandinavian artists, views the effect of modernism as claustrophobic. It is easy to imagine the ideal absent inhabitants of these interiors, contented, measured rational characters at home with homogeneity. These artists, by contrast, expose the underbelly of that rational culture

with relish, highlighting the problems surrounding the ingress of immigrants from other cultures, and celebrate the claims of the many strands of identity politics. Bjarne Melgaard, an artist whose work deals with gay sexuality, took a trip to Tahiti and once there masturbated over Gauguin's grave. The spectre of modernism haunts Scandinavia (so little time having passed since the funeral) and requires continual exorcism. Many artists are still busy hammering down the lid.

Even so, social democracy has left an imprint on this work which goes beyond mere repudiation. Unlike much similarly successful British work, Scandinavian artists show more concern with productive dialogue and the possibilities for improvement and less with vulgarity, pointless irony, and the voyeuristic spectacle of the unfortunate. Pissed off they may be, but they do not feel entirely powerless.

Nevertheless, the route down which these social democracies are moving is clear enough, judging by the conditions of democratic life elsewhere. Måns Wrange's project *The Average Citizen* examines the new conditions in which power has shifted from a politically constituted public to those who professionally manipulate public opinion and the political process. It takes the concept of the average citizen as modelled by the Swedish welfare state and, having identified one such statistically average

person and questioned her about her political opinions, has used professional tools including lobbyists to advance her interests. Her views have reached the public in political speeches and through the mass media. Polls are used to test the efficacy of these strategies, and one of the most effective interventions was made by putting her opinions into the mouth of a character on a popular TV series. This tart and amusing work places the change in public life under examination, mocking both the old attachment to the human mean, and the troubling corruption of the new system. It further suggests that the fragmentation of the social body under the pressures of economic recession and cultural divergence has played a part in opening politics to the manipulation of competing groups, the most powerful of which are moneyed.

David McNeill, in a fine article about art and globalization, tells of a notorious incident at the exhibition *Interpol* held in Stockholm in 1996 that brought together young Swedish and Russian artists who were supposed to act in collaboration. As the show developed, artists of other nations were added, and Chinese artist Gu Wenda produced a tunnel laboriously woven of human hair without reference to any other artist. At the exhibition opening, a Russian performance artist, Alexander Brener, ran through the tunnel, destroying it with a machete.

Police were called who arrested Kulik, in dog-mode trying to bite a child, though Brener escaped. While Gu Wenda saw his action as an act of Dada-inspired frustration typical of a degenerate and chaotic Russia, Brener was provoked not only by what he saw as shabby treatment of the Eastern European contingent by Western curators but also by the diluting of the original concept into a typical global love-in. Here is his own statement about his action:

The next day there was a news conference at which I was called a fascist. No, my dear chaps, I don't agree. At this exhibition I was the only democrat who had openly declared his position and demonstrated his disagreement with the organizers. Radical democracy in action! Bang on simulation and neoliberal vulgarity!

Cuba and China

Art from Communist nations in the era of the new world order has a different appeal than that from post-Communist states such as Russia. Cuba and China have up to now negotiated their survival in the new order in necessarily very different ways. In both nations, complex and various art forms are produced, and I can only sketch in an account here of a few examples that have been successful globally.

Diverse work that broke with the precepts of socialist realism

began to be produced in China following the end of the Cultural Revolution, some bearing on religious themes, some fomenting a Marxist humanism, and some (from the late 1980s onwards) engaging with the new and fast-growing consumer culture. Global interest was directed at Chinese art in the short term because of the massacre of dissidents in Tiananmen Square in June 1989, which led to considerable focus on artists who could be read as oppositional. Long-term worldwide attention focused on the extraordinary emergence of regulated markets in China and the generation of great wealth and inequality all at once; there was also (unlike in Russia) a marked average improvement in living standards for most people, and the creation of a vast pool of consumers.

The artistic trends that followed these dramatic changes are plotted by Gao Minglu, who notes that by 1988, as capitalist development in China accelerated, those artists, including Wang Guangyi, who had been concerned with grand spiritual and humanistic themes tended to forget them in favour of more explicit social comment. Wang called for the enthusiasm for humanism to be liquidated, stating that art is created only to achieve success in the media world and in the market. One major element of this new work was a resurgence in representations of Mao, suitably reconfigured to fit the new political and cultural

climate. This was Mao seen through the lens of Pop Art, in an image simultaneously kitsch and nightmarish.

The situation of Cuba is very different, of course, being a small island nation close to the hostile US which continues and even strengthens its trade embargo, and threatens worse. Relations with the exiled Cuban population are fractious and even dangerous: Gerardo Mosquera, a well-known and important curator, historian, and critic of Latin American art, had an invitation to speak at the Miami Center for the Fine Arts in 1996 withdrawn, because the fact that he maintains a residence in Cuba made him unacceptable to the likely audience; the Cuban Museum of Art and Culture in Miami was twice bombed because it shows resident Cuban artists. In another way, however, Cuba is well suited to the new globalized situation because of its ethnic and cultural mix, and relatively harmonious synthesis of African, European, and American elements.

The initial reaction of the regime to the fall of Eastern European Communism, and the sudden cessation of Soviet subsidies, was a crackdown on artistic freedom: avant-garde shows were closed, the government minister who had sanctioned them was sacked, and the artist Angel Delgado—who had publicly defecated on a copy of the official Communist Party newspaper, *Granma*—sent to jail. In response, most of the

Mao and Castro respectively, spliced with commercial advertising material (see plate 3). The image of Castro turned up in Pop representations, just as Mao did in China. José Angel Toirac had Castro appear in a Calvin Klein Obsession ad, the obsession here being the US determination to remove him. When a cigarette-smoking Castro crops up riding a horse in Toirac's Marlboro ad, it becomes evident what compact is signalled by the title of the series, *Tiempos Nuevos*, or *New Times*. He has also reworked famous documentary photographs of the Revolution using his friends, and playing up the rhetorical quality of the originals.

Such parallels should not be surprising, for both the Chinese and the Cuban governments have relaxed their hold on their economies, allowing limited private enterprise; they have necessarily changed their rhetoric in the process, allowing competing models of commercial publicity to creep in. So both populations are assailed with state and corporate propaganda, each striving to convince them of the singularity of their products. In the West these works play sweetly both as registers of the decline of once fearsome enemies and ideologies to the level of mere image, and as examples of cultural hybridization. This relaxed attitude towards actually existing Communism allows the incorporation of its symbols into contemporary culture with no more frisson of danger than the appearance of

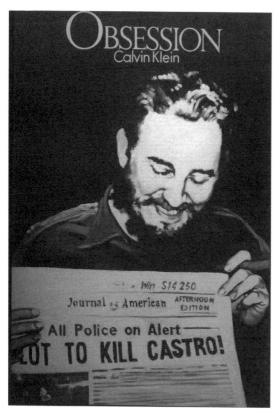

6 José Angel Toirac, Obsession.

Che Guevara's head on a T-shirt.

There are other similarities. The critic Li Xianting described the new avant-garde as 'anti-rationalistic and anti-idealistic, against metaphysics and heroism', and thus postmodern. Likewise in Cuba, Eugenio Valdés Figueroa cites the manifesto-like statement of an alternative Havana art-space, Espacio Aglutinador:

The possibilities for error are infinite.

If there is anything that AGLUTINADOR avoids like the plague it is coherence, that boring and nauseating 'goodness' of the conscience (p. 20).

Works such as Tania Bruguera's feminized Tatlin gliders—which render Russian Constructivism in delicate, gauzy materials—are just one example of that abjuring of coherence. They bring two sets of opposing terms into a single sculptural form, marrying masculine and feminine, engineering and dressmaking, utopian construction and bricolage in a compact that reflects critically on each of the terms. As is conventional in contemporary art, no synthesis or resolution is on offer.

In both nations, the work that is most successful on the global scene acts out overt Chineseness or *Cubanismó* for a Western audience. With much prominent Cuban production, for example in the work of Kcho and Los Carpinteros, there is a strong

element of bricolage and low-tech production, of creative invention with gleaned materials, and the use of old craft skills. This is partly no doubt out of necessity, but is also a meeting of Western expectations about Cuba. Two of China's most effective exports, Gu Wenda and Xu Bing (now both living in New York) take as their main medium of expression Chinese calligraphy. More generally, the criteria for inclusion are quite obvious—work should reflect Chinese conditions that are well known and of concern in the West: political repression, economic growth and consumerism, the subjugation of women, and the control of family size. These overtly 'Chinese' concerns should be expressed in recognizably contemporary Western modes to produce a manifestly hybrid object.

This was made very apparent to me on seeing a selection from the *Ninth Chinese National Art Exhibition* shown in Hong Kong in 2002. The painting section of this show was a large, impressive display of socialist realist depictions of contemporary Chinese life, painted in a wide variety of styles, and often technically very accomplished. Some work, such as Wang Hongjian's melancholy painting of migrant labourers waiting for transport home in the moonlight, spoke directly and eloquently of people's experiences in a rapidly changing society. Other pieces, such as Zheng Yi's portrait of broadly smiling rural folk in

the sunshine, seemed (to my eyes) hopelessly kitsch—*Plain Souls Burn Bright* is not a title you would get away with irony-free in London or New York. Lacking the required Western references (there were many, in fact, but to older styles, including impressionism) and the appearance of uselessness, since they all had some propaganda function, they were genuinely different from Western productions and therefore invisible to the global art system.

By contrast, we can look at two global successes, Xu Bing from China and Kcho from Cuba, whose work is representative of what is looked for in such art. Xu Bing, a staple of the biennales, became celebrated for a work he showed in Beijing in 1988, Book from the Sky. This was an extraordinarily labour-intensive fabrication of 1250 invented characters, derived from the elements of Chinese ideograms but meaning nothing. These characters were used to create large, impressive installations of scrolls and books, presenting Chinese readers with the appearance of great expanses of meaningful text, all of it obdurately unreadable. It is an ongoing project, changing as it is installed in different venues, adopting computer technology and spawning collectors' books. The work proved extremely controversial in China, where it was both attacked and defended, and it became associated with the avant-garde production put

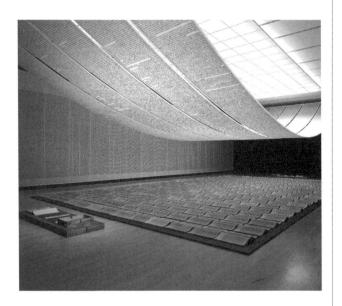

7 Xu Bing, A Book from the Sky.

under pressure by the authorities following the Tiananmen massacre. Xu Bing himself, cited by Stanley K. Abe, said of the work's noisy public reception, following the long period of solitude during which he had made it:

Handing one's work to society is just like driving living animals into a slaughterhouse. The work no longer belongs to me: it has become the property of all the people who have touched it. It is now concrete and filthy (p. 243).

In a remarkable article Abe charted the various readings of *Book from the Sky*. Once exported from China, the work changed profoundly, for most of the new audience could not attempt to read the characters or sense their strange familiarity. When it was seen in the US, it was only through the lens of Tiananmen, as an allegory of good (individual expression) versus evil (oriental despotism). Xu Bing did not sanction these readings but neither did he reject them. In any case, as the reading broadened out from the concern with Tiananmen, it was only ever read as a critique of Chinese traditions, institutions, and history, and never, for example, as a general comment on meaning as such.

Gao Minglu has put the matter of misreading forcefully, writing of how critical avant-garde activity gave way to a pragmatic neo-avant garde that strives to transcend the local in favour of acceptance in the international arena. This shift is largely

makeshift boat skeletons, sculpturally spliced with references to European modernism (in this case, Brancusi's *Endless Column* of 1938), which clearly refer to the tragic attempts at exodus of Cubans following a US declaration that all who made it to their shores would be accepted as citizens. As with Xu Bing, a manifestly national subject, rendered with an artisan's skill, is framed within an acceptable contemporary art format.

Much of this art, while it draws on the resonance of political issues, takes no stand, and is characterized by ironic or mute politics. Coco Fusco, in an article for the archly cool art magazine Frieze (and reprinted in her The Bodies that Were not Ours), tried to put the politics back into Kcho's work, particularly by looking at its use by the authorities in the Havana Biennial. For such cheek in analysing a new darling of the market she received threats, and the magazine had to deal with complaints from Kcho's dealers. It says much about the level of art writing in such magazines—and the degree to which powerful dealers and art institutions ensure servile 'criticism'—that such an article should stand out so dramatically from the critical landscape. There is generally little need for threats and complaints, of course, since most writers effectively censor themselves. As the scurrilous art magazine, Coagula, points out, this is particularly pathetic behaviour on the part of writers because (with very few exceptions) they do not

New world order

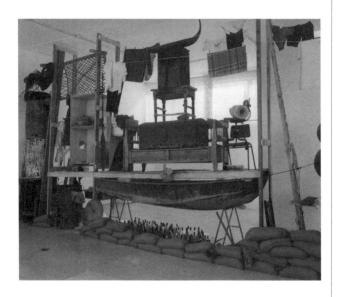

8 Kcho, Speaking of the Obvious Was Never a Pleasure for Us.

New world order

even make any real money out of the scene.

In much prominent global art, identities parade for the entertainment of cosmopolitan viewers. Features of cultural mixing, irony, and the overt performance of identity are comforting to the Western eye, which (as Slavoj Živek controversially argues) is only comfortable with otherness as long as it is not really other. The results have been well summarized by Fusco: that globalization has transformed the art world along with the management of racial and cultural difference to follow the model of corporate internationalism. Visibility in the realm of culture is no guarantee of political power, and the increasing privatization of cultural institutions erodes the influence that once might have flowed from that visibility. Instead, diversity is normalized while its critical content is sidestepped. The point can be made most literally by looking at the migrations of the artists themselves: their origins may be diverse, but so many end up living in New York—the great art vortex—and by no means just those who have fled states with legal censorship. Thus multiplicity produces homogeneity, as all must undergo the sanctioning of the marketplace.

Yet much of this art, despite its dubious attractions in the West, does say fascinating things, and does work at a level of intensity and engagement very rarely found in comfortable and

settled societies. Writing of theory, Fredric Jameson has convincingly argued that the most systematic works are produced in circumstances where, due to combined and uneven development, thinkers are faced with extreme contrasts of scene. as if they lived in an environment where it is easy to step from one historical period to another. Peasants in paddy fields may raise their eyes from their work to alimpse a new neighbour, a high-rise postmodern office complex. Such variegated environments, argues Jameson, foster systematic and totalizing thinking about historical change. With art, there is no expectation of such systematic qualities, but those circumstances do have an effect, particularly in fostering an engagement with issues beyond the ubiquity of consumer culture. Equally, one would expect the flatt-est, most fragmentary, and most defeatist art to be produced in the oldest and wealthiest neoliberal economies, particularly the US and UK—and indeed it is, as we shall see in the next chapter.

What has been briefly examined here is not the full panoply of global art production, which is very varied and produced for all kinds of diverse local conditions, but rather what is filtered through the art world system to international prominence. While that may be produced for the most part with a global art elite in mind, the art world is leaky; despite the hegemony of the US, and

New world order

lock-hold of the professionals, its products have a wider resonance among a diverse audience, many of whom continue to hold to the utopian belief that art carries a wider message. For them, it may offer various, and sometimes even radicalizing, experiences.

Even so, the much-trumpeted diversity of the globalized art world conceals other, newer uniformities. Just as global capitalism stepped out from behind the cloak of its defeated opponent after 1989 and, in its rapid transformation, was revealed as the rapacious, inexorable system that it is, so it may be with the art world. The end of its use as a tool in the prosecution of the cold war has made clear a new role already in development: its core function as a propagandist of neoliberal values.

If the economic expression of neoliberalism is sharper inequality, and its political expression deregulation and privatization, then its cultural expression is surely unrestrained consumerism. While the 'new world order' caused the art world to refashion itself by globalizing its operations, in the developed world particularly art came under intensifying pressure from its old rival and partner, mass culture. Since at least the early years of the twentieth century, with the invention of cinema, the phonograph, and radio, the two have engaged in an unequal dance, mass culture generally leading.

Contemporary artists tend to handle the issue of consumer culture with fascination and nervousness, and there is good reason for both reactions. Fascination, because consumerism appears to become ever more cultural, as much concerned with selling or merely displaying images, sounds, and words as it is with material things. Nervousness, because the engines of this production are so vast and lavishly funded, their output so strident and omnipresent. If commodities tend towards being cultural, what space is left for art?

It is an old worry, found in modernism as well as in postmodernism, though in different forms. Fernand Léger stood before the machine exhibits of the Paris Fair in 1924, marvelling at how such immaculate productions outshone the poor, self-

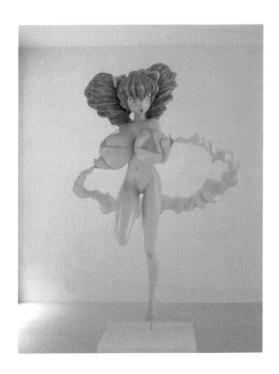

9 Takashi Murakami, Hiropon.

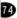

conscious efforts of artists. The argument that art is no longer possible because the world of products is saturated with aesthetics is the postmodern variant of the same anxiety; a modernist dream of the merging of art and life has also apparently been realized, though less in synthesis than the surrender of the weaker party.

While the issue of art's separation from or mergence with commodity culture has a long history, during the 1990s there was an intensification of the forces involved—many of them old features of capitalism—that contributed to the dominance of a triumphant consumer culture not just over art but over all other cultural production. Commodities seemed to become even less like functional objects and more like evanescent cultural moves within a sophisticated, self-referential game. Brand names hopped between products unrelated in all but name, while advertising churned over reference, self-reference, and metareference in an accelerating consumption devouring of old and new cultural attachments. The greatest profit continued to be made not in industry but in services, data processing, and finance, and the success of those sectors was most associated with the neoliberal economies, particularly with the US. In the West this change had been felt as early as the mid-1970s but the 1990s saw the collapse of alternative models, not only in Eastern

Europe but also in the great industrial economies of Germany and Japan, which both suffered stagnation and decline.

Continental Europe moved to embrace the neoliberal model, sugar-coated though it was through much of the mid- and late 1990s with nominally social-democratic governance. Like commodification itself, the neoliberal model widened its ambit and deepened its hold.

We have seen that in some of these territories (including Scandinavia) which recession had newly opened to unrestrained and corrosive market forces, art served as an agent of neoliberalism, trampling over the comforting if suffocating amenities of social democracy, and giving expression to the liberated concerns of identity politics, consumerism, vulgarity, and pleasure in the degraded. Such works opened up previously suppressed perspectives, and in doing so served as useful, if minor, allies of privatization and the colonizing force of commodification. The parallels between the orthodoxies of postmodernism and the free market ethos have often been drawn out. Michael Hardt and Antonio Negri, in their influential book *Empire*, put the matter well:

The ideology of the world market has always been the anti-foundational and anti-essentialist discourse par excellence. Circulation, mobility, diversity and mixture are its very conditions of possibility. Trade brings differences

Corporate culture has thoroughly assimilated the discourse of a tamed postmodernism. As in mass culture, art's very lack of convention has become entirely conventional. Ubiquitous and insistent voices urge consumers to express themselves, be creative, be different, break the rules, stand out from the crowd, even rebel, but these are no longer the words of radical agitators but of business. The writers of the US magazine of cultural analysis *The Baffler* vividly describe the extent and standardization of these injunctions. Their wonderfully condensed example of this imperative is William Burroughs' appearance in an advert for Nike. Much in the art world since 1990 has offered a tame exemplification of those virtues purloined by corporate culture.

Postmodern theory itself, as it moved from being an account of a potential utopia or dystopia to being a flat description of an existing reality, lost its critical and ethical force. In its reduced state, consumerism and the supposed empowerment of the shopper were central to postmodernism's disquisitions. While in the 1990s postmodern theory was buffeted by attacks on its internal absurdities and its browbeating of readers with meaningless scientific jargon (highlighted in the Sokal affair), in much of the academic art world, at least, it was less replaced than lost sight of by its acceptance as the unargued background out of which statements about art were made.

Much postmodern theory insisted that simulation had so thoroughly saturated world and thought that there was no telling where representation ended and reality began. Yet the ghostly, apparently immaterial character of the contemporary commodity goes hand-in-hand with the rise of neoliberalism. This militant form of capitalism was made possible by farreaching technological changes, particularly in computer communications, that made the exchange of information cheap, quick, and simple. As Dan Schiller has recounted in *Digital Capitalism*, the building of vast computer networking infrastructures was driven by profiteering on the privatization of publicly owned telecommunications industries. The digitization of data could turn previously free information (for instance, in libraries) into commodities, in an enclosure of data commons.

Another striking development tended to make the commodity appear less material: branding achieved greater importance throughout the 1990s as corporations spent money on their own images that they had saved on outsourcing production. Naomi Klein argues in her justly renowned book *No Logo* that, as production was exported to low-wage economies, so the link between the consumers of a product and its makers was sundered. The brand was elevated in compensation, floating free of mere products, to become an allegorical character, a

reliable embodiment of particular combinations of virtues or admirable vices. Sometimes, as with Ronald McDonald, it solidified into an animated figure.

While commodification has generally expanded—so that, for example, sequences of genetic code are patented and companies advertise in schools—limits are still drawn. John Frow lists some areas, such as religion, aspects of personal life, politics, and art that, while not free of the effects of commodification, are not subject to the strict demands of profit maximization. Frow is right that there are areas of life that are comparatively free from commodification, but if, in reading the list, the word 'art' is stumbled over, perhaps it is because art and business have been drawing nearer to each other.

On going to the links page of veteran conceptual artist Claude Closky's web site, the viewer is presented with an alphabetical list of .com sites composed of familiar names, a roll call of contemporary art stars: it begins adams, akerman, alys, amer, andre, araki. All the links are in fact to company sites, so clicking on www.billingham.com, for example, takes you to a site selling camera bags. The range of products and services brought together that share artists' names forms a curious little database, and the work encourages the user to think about artists' names as brands, and about the .com character of their work.

As commodities have become more cultural, art has become further commodified, as its market has expanded and it has become increasingly integrated into the general run of capitalist activity. Even in the early days of postmodernism, Adorno recognized the parallel between art and consumer goods, especially during economic upturns:

... where the material use-value of commodities declines in importance, where consumption becomes vicarious enjoyment of prestige ... and where, finally, the commodity character of consumables seems to disappear altogether—a parody of aesthetic illusion (pp. 25–5).

The result is an attitude to art that is similar to people's attitude to commodities that themselves pretend to be no less than art. Yet this is no irreversible or inevitable historical development, born out of the revealed essence of art and commodity, but one that is tied to the rising and falling rhythm of the economic cycle, and enjoyed only by those wealthy enough to consume conspicuously.

A number of artistic practices in the 1990s responded to these changes, feeding off them and pushing them further. Sylvie Fleury took the results of her shopping trips to high-class boutiques and laid them on the gallery floor; or she placed desirable, fashionable items (literally) on pedestals. Fleury also

examined different levels of consumer activity, bringing the least glamorous and most utilitarian into contact with conspicuous consumption by gilding supermarket shopping trolleys (see colour plate 7). Guillaume Bijl simply opened shops within the museum. For the Shopping exhibition at Tate Liverpool a gallery was turned over to Bijl's branch of the supermarket Tesco. This was maintained by Tesco staff who went about rearranging goods, tidying shelves, and repricing. Yet, since no one could actually buy anything, and all the shelves were fully stocked and lit by museum spotlights, the 'shop' became an aesthetic display of multicoloured blocks of repeated packages. In one sense this was reminiscent of Fleury's shopping trolleys in making the least aesthetic of shopping experiences into an isolated visual spectacle. It discomfited viewers, who were little used to the implied expectation that they should look at the commercial display of tinned goods as connoisseurs. In another sense that discomfort served as a minor refutation of the position (found in Baudrillard's writings) that the aesthetic has long completed its invasion of commerce.

Reading some postmodern pronouncements one might be forgiven for thinking that no area of culture is immune to art's invasion. This is in fact hardly the case, and the art world selects its alliances with some discrimination. There is no sustained

interest in darts or pigeon-fancying. By contrast, there has been much effort to bring art and fashion closer together. A bland statement by Hugo Boss (the sponsor of a Fleury show) reveals through and because of its jumbling of terms the ideological mechanism at work:

Art and fashion have always gone hand in hand. Sometimes radical and shocking, sometimes traditional and conservative, both are judged according to subjective standards of taste. Each represents in its own way the moods and spirit of the times. They stimulate the senses and create objects of desire as fetishes of an affluent society and legacies of culture.

Through the 1990s, art and the fashion industry came into increasingly close contact. Art magazines carried more adverts for Prada, fashion magazines contained more features about contemporary art, and genuine hybrids appeared (such as *Tank* or *Very*) in which the two worlds acted in symbiosis. Numerous fashion photographers such as Jürgen Teller and Corinne Day produced art books, and their work appeared in galleries as well as on the page. Diedrich Diedrichsen relates the vogue for spectacular art works both to a marked improvement in magazine print quality leading to a greater use of pictures (displacing text), and the growth of crossover art, style, and fashion magazines. Such publications naturally tend to reproduce

art that can be grasped rapidly just by looking at it, and will exclude that which cannot be adequately represented in a photograph or two.

These developments were linked both to the pressures placed on public galleries and museums to commercialize themselves and to the predilections of exhibition sponsors, but they also reflected a much wider trend in commodity culture to favour youth, or at least its appearance. Youthfulness is an appealing marketing quality even for those art events that attract older audiences, which like to think of themselves as sprightly. Youth became an advantage that artists could trade upon in various ways. Artists can remain young for quite a while, or even be labelled 'young'. They can depict the young, and there is a rash of such portrayals, particularly in photography, where the poignancy of ageing and death is always implied. So Rieneke Dijkstra's adolescents pose painfully before the camera on beaches or in clubs; or Sarah Jones's privileged but anomic girls array themselves across decorous rooms, melancholic with some secret knowledge; or, in a different register, Vanessa Beecroft's performances, videos, and photographs use models who stand about in various states of undress, confronting the viewer with the guilt of their own desires and aspirations. All of these works can be read as critical, and all equally can be enjoyed as culturally

distinguished renderings of beautiful youth (colour plate 4). Finally, artists can perform in their work as if they were youths: Georgina Starr, Elizabeth Peyton and many others act out obsessive adolescent fan culture, while in overt opposition to the mastery of consummately mature and accomplished artists like Bill Viola, who continue to carry the torch for genius and aesthetic quality, is the light relief of the self-consciously pathetic and underperforming, as in the antics of Sean Landers.

Among those who have inhabited the world between the gallery and the magazine, one of the most successful is Wolfgang Tillmans. He made his name with stylish, loose, snapshot-style work for magazines such as *i-D* and *The Face*, but has also regularly shown in galleries and museums. He won the Turner Prize in 2000 and had a major show at Tate Britain in 2003. Tillmans' subject is youth, and his eye (it should be inferred from the casual character of his work) is the innocent eye of youth, which fixes with wonder on each visual fragment of the world, whether banal or provocative. The film on a cup of black coffee, a rat escaping down a drain, a penis beside a bedside breakfast tray are fixed with the same stare. That vision, as you would expect, also finds beauty in unexpected places, as in the picture of candy-coloured blocks of air-freshener reflected in the slick metal surface of a urinal

Tillmans' world is the arena of a segment of privileged, mostly white youth, and aside from people in fashionable clothing, he depicts clubbers and Berlin's Love Parade. These are set alongside a set of youthful political concerns—gay pride festivals, homelessness, and opposition to war. All this is gilded with the spirit of youth itself, with its directness, sexiness, idealism, and melancholy awareness of its own transience (indicated in Tillmans' photographs, entirely conventionally, with wilting flowers and over-ripe fruit). Tillmans' work is useful because it is so representative of a great swathe of art-fashion production in magazines, books, and exhibitions in which just the same attachments are aired and the same values assumed. With the weight of the commercial culture's obsession with youth behind it, this vision has considerable momentum. To take against it would automatically condemn one to seem churlish and fogeyish.

It should be asked: do these photographs reflect on the tensions inherent in the youth cult or merely exemplify them? Do the juxtapositions between pictures build significance or just suggest it? Tillmans has said that in photographing gold ingots he indicates something meaningful about money and value. An old remark by Bertolt Brecht is useful here: a photograph of a factory tells you nothing about the relations between the people

inside it. The title of his Tate show and book—If One Thing Matters, Everything Matters—gives the game away, as well as reflecting the recent art-world prejudice for the straightforward depiction of the 'real'. What is really being granted here are various naturalistic glimpses of objects and people. Access to the real demands a higher price—in thought, knowledge, and the building of structures, and in the realization that some things do matter more than others.

All this should not lead us into thinking that art and fashion have merged, any more than art and mass culture as a whole have done so, or art and entertainment (as a recent Walker Arts Centre show suggested). The mutual attractions would not hold if the crossing between poles did not produce some useful spark—of cultural distinction and seriousness for fashion, and glamour and fashionability for art. How is this separation maintained? Professional art discourse is one route, and linked with this the way art works very frequently refer to other art works, requiring of adept viewers a knowledge of history and the contemporary field, as well as art jargon. We shall also see in the next chapter how art holds back from any threat of merging with the wider culture by defending its autonomy through aspirations to professional status.

Yet perhaps fusion with fashion or entertainment is less of a

threat than total identification with the commodity itself. If that took place, art would lose all pretensions to idealism and all justification for state subvention. For Marx the commodity is a strange and complex thing, being at once a material object valued by its buyer because it has a use and, because of the action of the market, a bearer of monetary exchange-value. While uses are diverse and incommensurable, exchange values are all set on a single scale. For Benjamin Buchloh, in his pessimistic accounts of contemporary art, use-value is increasingly surrendered, and art (like money) has become a commodity of nearly pure exchange-value. (As long as they remain material objects, neither money nor art can shed all use-value; as Mayakovsky recounted, during the Russian Civil War books were printed on money, which had gone out of use, while in Duchamp's infamous provocation, a Rembrandt could be used as an ironing board.) In a further stage, even the pretence of achieving use-value in art is dropped, as artists simply reflect and examine the new scene in which there is no distinction between art and commodity culture, and they do so without critique or the desire for change.

It has become a standard tactic in Western contemporary art to refuse to take sides in a work, or in talking about it. A work will present a conundrum (the combination of a depiction of the Virgin

with crotch shots from pornographic magazines, to take one controversial example) and let the viewer decide the meaning. The model here is Warhol, of course, who talked and wrote a lot but only in words that issued from his branded persona, so that no one could be sure of their status: Being good in business is the most fascinating kind of art.' As art draws nearer the standard commodity it would be foolish to expect critical comment on a product by its maker. So in Bijl, Beecroft, or Fleury, it is unclear whether the fashion industry and consumerism are celebrated or condemned. Such works simply highlight the existence of commodities or models by making them seem strange, above all by altering the environment in which they are seen. Yet, despite the artists' and critics' statements that surround this work, and assure the viewer of its neutrality, the ambivalence is far from complete. Such work is modest and weak if taken as critique. strong and strident if taken as celebration, since after all particularly in the work of Fleury and Beecroft—what is glossily and cannily produced is another set of commodities, and the publicity and sponsorship arrangements through which they are seen and sold. To consume these goods, bearing the tinge of a critique of themselves and their consumption, is the very definition of 'camp', which Susan Sontag argued long ago is the tactic intellectuals employ to sanction their enjoyment of mass culture.

Thus art, a material manifestation of exchange-value, approaches the condition of that most abstract of commodities, money—and it is actually used like that by the rich, as a quasiliquid form of speculative capital, with the consequence that great numbers of the objects in which that value inheres are locked away unseen in secure, purpose-built depositories.

Yet there are disturbances to this simple scheme of art and other commodities growing closer in character, as are galleries and shops. The materiality of the art object persists, even for video and media art, which has generally been accepted as art only by paying the price of becoming partly material. The art market is still dependent upon the buying and selling of rare or unique objects far removed from the mass-produced commodities found in ordinary shops. In most markets a few dominant companies control production, but there are few in which consumption is regulated. The commercial art world tries to hold both reins tight, for the buyers of these objects are few and known to the sellers, production is often artificially limited, and patronage often has a personal dimension. To look at the contemporary art world is to take a glimpse into an older, preindustrial market system. A suggestion of this difference is found in Andreas Gursky's various photographs of top-flight shops and famous galleries. The shops seem to reproduce the forms of

minimalist sculpture with such pristine perfection that matter becomes uncannily spectral, while in the galleries the muddy craft character of the objects displayed is evident, for instance, in the ragged shadows that paintings cast on white walls.

Above all, while ordinary commodities live or die by millions of individual decisions to buy or not to buy, the feedback mechanisms which determine the track of contemporary art are regulated and exclusive, and the ordinary viewer of art is permitted no part in them. Vitaly Komar and Alexander Melamid highlighted this issue by applying the standard methods of the consumer questionnaire to painting, producing results that cater to the average taste of different national populations. The results were a series of hilarious and surprisingly uniform paintings, in predominantly blue tones, in which charismatic animals and famous historical figures populated idyllic landscapes, optimal for human survival.

Separated from the full rigours of the market, art can flirt with consumer culture while remaining assured of its safe demarcation. Indeed, those works that appear to threaten such a merging of art and the commodity (like Bijl's) actually reinforce the boundary by making it visible. Another way of ensuring that the distinction remains clear is to turn the gaze inwards, as within a mirrored box, so that reflections assume an unwarranted

significance, and artists' moves tend to be seen in relation to those of other artists, and rarely within the context of the outer world. Recursive games are played with predecessors' work, as well as with material drawn from mass culture. Thus Mike Bidlo appropriates Warhol's appropriation of Brillo boxes, transforming the appropriation of a consumer item into the appropriation of art, while suggesting that Warhol's images have themselves become reduced to consumer items.

This specialist insider discourse provides only the illusion of escape from the commodity form. Marx pretends that the fetishized commodity can speak of its own condition, and this is what it says:

our use-value may interest men, but it does not belong to us as objects. What does belong to us as objects, however, is our value. Our own intercourse as commodities proves it. We relate to each other merely as exchange-values (pp.176-7).

While art seeks to protect itself with internal discourse in works and words, so that apparently the most important things to say about art relate it to other art, it only emulates the play of free-floating exchange-values that are most evident in times of glut.

From the moment it was established, the safety of the enclave has, of course, been challenged by artists. This was part of the point of sticking newspapers to canvases, trying to put signed

and dated urinals into galleries, or—more radically—making art act as the servant of mass production. Yet while those challenges were tied to time and context, the objects in which they were incarnated were not, and as they persisted through history, their tinge of radicalism added to their aesthetic lustre and market value as they became increasingly conventional art commodities.

As mass culture became steadily more spectacular and immersive—with larger high-definition TV sets and vast cinema screens, with the enclosed and carefully calculated spectacle of the shopping centre or theme park—art had to compete. It could do so, as we have seen, by feeding off the allure of mass culture while adding its own aesthetic and estranged edge. It could compete by reversing the norms of mass culture: to take video as an example, it could produce slow, portentous pieces without camera movement, narrative, or obvious meaning, to set against the standard moral tales and visual incident of TV. It could provide impressive, non-functional objects and environments that, unlike those of the mall or resort, were not geared to selling (or at least not to the vast majority of their viewers). Lastly, it could make representations of a scale, richness of colour, and definition unknown in the mass media.

This last tactic has produced some of the most commercially successful work of the 1990s and beyond: large-scale colour

photography. Such photographs, made with large-format cameras, printed to the scale of grand painting, sometimes on aluminium panels, convey visions of the contemporary world which have a startling clarity and depth of colour. These photographs tend to be produced in small editions and at different sizes, making them as suitable for the museum as for the collector's living room. In the recession of the early 1990s, museums looking for spectacular and accessible works bought many of these pieces, and their prices began to climb steeply as a result. Now prices rival those of the top painters; in 2002 a large Gursky was sold for over £400,000 at auction, a record for a contemporary photograph.

There is an art-historical line that may be traced back from the heights of the most successful German art photographers (Gursky, Thomas Struth, Candida Höfer, Thomas Ruff) back through their teachers at the Düsseldorf Kunstakademie, Bernd and Hilla Becher, and through them to that extraordinary ethnographer of the Weimar Republic, August Sander. Read one way, it starts with Sander's belief in the power of photographs in long, comparative series to convey social knowledge, through the Becher's strange serial mourning of the forms of industrial modernism to, say, Ruff's insistence in his six-foot-tall passport-style portraits on the medium's inability to convey anything

meaningful, no matter how much detail it throws at the viewer. Tracing that line in the gallery (rather than in reproductions) something else is obvious: Sander's black and white prints are finely made, and little larger generally than a hand; the Bechers, too, worked in black and white and printed at different sizes, often mounting their prints in grids in a single frame to create a work that is four to five feet across; the work of the next generation bursts into rich, saturated colour and for the most part massively outgrows its predecessors. The largest Gurskys and Struths, up to 17 feet long, allow the viewer to step right up to them, examine their serenely grain-free surfaces and myriad detail in their scale, production values, self-conscious gravity, and expense they appear to be the new history painting, and like history painting, they were made primarily for the museum.

Much of this work has increasingly paraded its artiness: Struth's early street scenes turned Sander's eye and technique on the physiognomy of the city in modestly scaled, subtly composed black-and-white pictures; Gursky's took the casually framed, washed-out look of old amateur photographs and applied them to banal holiday scenes and bored spectators. This work reflected variously on the legacy of modernism. Ruff has taken pictures of buildings by Mies van der Rohe, draining them of bright colour to give them an antique look, accentuating the ageing of the

buildings; or he has dully colourized old photographs to similar effect. Struth and Gursky documented the system-built structures of industrial estates, office complexes, and the leisure industry. More recently, the art-historical references have widened. Both Gursky and Struth now leave the viewer in little doubt about what they are seeing: their lavish productions frequently refer to painting, and often they take the gallery itself as their subjectmatter. Both have recently had shows in New York's most important art museums—Gursky at the Museum of Modern Art in 2001, and Struth at the Metropolitan in 2003. The exhibitions and their catalogues put the seal on photography's graduation to the pinnacle of art, and the texts (particularly Peter Galassi's on Gursky) made more reference to parallels in painting than photography. Art is thus ratified by reference to other art, and photography is remade as a spectacular creature of the museum. Their modest early photographs encouraged a critical reading of their subjects and matched banal scenes to deadpan photography; their latest productions tend to transform contemporary scenes into epic, even sublime, spectacles, and tend to foster wonder rather than thought.

Contemporary art still defines itself against mass culture, and necessarily so because of its shunning of mass production, which has a further effect on its subject-matter. Marx argued that

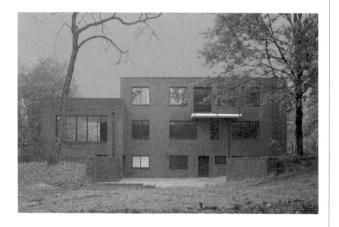

production and consumption are bound up with one another to the point of unity. Not only does one depend upon and complete the other, but production always involves consumption (for instance, of raw materials), and consumption production (for instance, eating sustains the labouring body). The exclusive focus on consumption in much of the art world is an ideological matter, one that flows from the prominence of advertising and other corporate propaganda, for which the less consumers think about production (who labours and for what pay, in what circumstances and at what risk, under what form of coercion. with what environmental consequences?), the better. This blindness is reinforced by the art world's own archaic production practices, which separate it from the regular business of mass production. There are huge numbers of art works that have dealt, for instance, with the uncanny character of toys in the realm of consumption (to take a few varied examples, in the work of Martin Honert, Mike Kelley, Mariko Mori, and Georgina Starr); few touch on the equal charge of the contrast between their intended use and the circumstances in which most of them are made—in China, say, by the harshly disciplined labour of young women who shuttle between unsafe factory and crowded dormitory.

There are a few artists who bring the fields of production and

consumption into connection and contention. Gursky's photographs, of shops and galleries as well as factories, examine the cultural rather than the economic unification between consumption and production. His depictions of, say, a Grundig factory, the Pompidou Centre, and a 99¢ thrift store show muted human figures dominated by large-scale grids. These can act as textbook illustrations to Theodor Adorno's arguments in his essay 'Free Time' about the secret affinity and interdependence of work and leisure, in which leisure, only apparently partitioned from work, adopts work's structure and forms. That such thinking takes place in the work of a German artist has a number of causes. One is the long success of the German industrial economy, which has nurtured in many of its artists a concern with production driven from the minds of most artists in the rapidly deindustrialized US and UK. That concern has also led Gursky and Struth to take pictures in comparable economies, including Japan and Hong Kong. Another (and linked) cause was the continuing liveliness of modernist thinking (including the work of Adorno) in Germany, after the triumph of postmodernism elsewhere. Yet generally in the 1990s consumerist spectacle—suitably spun for art-world taste—prevailed over critical thinking about the interrelation between production and consumption. In the final chapter we shall see how this has begun to change.

4 Uses and prices of art

Avant-garde art, lately Americanized, is for the first time associated with big money. And this because its occult aims and uncertain future have been successfully translated into homely terms. For far-out modernism, we can now read 'speculative growth stock'; for apparent quality, 'market attractiveness'; and for an adverse change of taste, 'technical obsolescence'. A feat of language to absolve a change of attitude. Art is not, after all, what we thought it was; in the broadest sense it is hard cash. The whole of art, its growing tip included, is assimilated to familiar values. Another decade, and we shall have mutual funds based on securities in the form of pictures held in bank vaults.

(Leo Steinberg, 'Other Criteria', lecture given at the Museum of Modern Art, New York, in 1968)

This passage, read nearly forty years on, has the peculiar quality of being both surprising and familiar. When Steinberg wrote this, contemporary art was still settling into its accommodation with money as the market outgrew its old condition as a tiny and specialist area, and there was brief wonder at the resulting change of scene. While that scene has become simply the accepted environment within which art operates, the surprise is due to the frankness of Steinberg's description. For now the general presumption is that it is either redundant or bad manners (or both) to talk about it.

Both making and selling are unusually controlled in the art

market. Dealers often sign exclusive contracts with artists who are then encouraged or instructed to produce particular kinds, sizes, and numbers of work. How often has one seen in commercial galleries decorative and wall-bound spin-offs of some apparently recalcitrant anti-commercial installation? For obvious reasons these urgings usually remain secret. Buyers are vetted for their commitment to collecting, since it can be dangerous to an artist's reputation or even to the market as a whole to have a sudden and unexpected sale of work. There is less regulation in the so-called 'secondary market' of the auction houses, but even there the market is hardly free, with the setting of reserve prices below which works will not sell, and the manipulation of bidding by collectors and dealers, aside from recent scandals over sytematic price fixing.

The situation is most starkly illustrated with art made in reproducible media; artists can cheaply produce photographs, CDs, or videos in large numbers, and try to achieve wide ownership of their work. Yet the great majority of them produce tiny editions, each piece being accompanied by a certificate of authentication, for very high prices. Ownership of such a piece grants status to the collector, and reciprocally the price paid grants status to the work.

This is the defining characteristic of art as against other areas

Uses and prices of art

of high culture: drama, the concert, or opera achieve exclusivity through requiring that an audience be present at a live performance (and of course high art can do this, too); other forms—novels, poetry, music, and film—produce objects that are industrially fabricated in large numbers and are widely owned. Only in high art is the core business the production of rare or unique objects that can only be owned by the very wealthy, whether they are states, businesses, or individuals.

When art was produced using craft methods, the supply of any artist's work was unavoidably restricted, and if demand for that work was high, then prices rose. There are still many artists who create value through the expenditure of large amounts of manual labour (their own or more often their assistants) on unreproducible objects. Yet through the 1990s more artists tended to use more technical and reproducible media—above all, photography and video—and the restriction of production has come to seem increasingly artificial. The situation gives rise to some very odd ways of making things. In his recent work Jeff Koons takes various commercial images, collaging and altering them using a computer (see Colour Plate I). When this process is complete, a giant print-out is generated which is then handed to Koons' assistants who (as Robert Rosenblum puts it in the Deutsche Guggenheim catalogue) 'with the clinical accuracy of

scientific workers' (p.56) make a saleable and unique rendering in oil on canvas. This final and most mechanical stage assures the status of the piece as a unique work of art.

The limit placed on supply makes the art market highly unusual, so much so that many economists have been reluctant to explain it using the usual terms. Normally, in shopping for (say) a tin of soup, price is matched against the buyer's desire for the product; similar or identical tins can be found in different places and at different prices, and those prices fluctuate with supply and demand. As Neil De Marchi describes the situation in a book on economists' thinking about the arts, little of this applies in the art market. Fashion—not calculations of usefulness—has a large effect on demand, disrupting the usual relation between utility and desire; many works of art are unique, disrupting the laws of supply, which become an all-or-nothing affair, so no equilibrium tends to be established as demand and supply respond to one another. Worse, in buying a unique object from a monopoly supplier, since there can be no comparison with other objects, there can be no reliable market information about the deal

In fact, the situation is a little more mundane: many art works are unique but this does not mean that they are not compared by dealers and buyers with works they deem similar—most notably, works by the same artist, though size, expense of

Uses and prices of art

materials, and the labour that has gone into a piece are also factors. Auction prices may be far from pure indicators of market judgement, but they are at least sometimes at variance with the prices set by dealers. Nevertheless, the market does remain short of information (much of it is kept secret), supply is regulated, demand managed, and pricing is highly susceptible to fashion and circumstance.

Contrary to widespread public perception, fixed on fantastic prices for major works achieved at auction, particularly throughout the 1980s and the mid 1990s (a perception that is, of course, much fostered by the auction houses themselves), art is not generally a good investment, certainly not over the long term, performing consistently worse than stocks and shares. While some categories of work do increase in value for a time, the real price of art often falls. Speculating in low-priced contemporary art is a very risky investment. Peter Watson has given a detailed account of art's economic performance, and argues that investment only makes sense over the short term as a risky speculation, and that large amounts of money are only made when art is sold during one of the market's spectacular booms. Unsurprisingly, then, buying art which is already highly valued is almost always a bad investment. Over the long term, various studies have shown that investment in art performs

about half as well as other types of investment. This is the price paid for owning art, and it explains why relatively few wealthy people collect. Of those that do, many collect for pleasure and prestige as much as investment. For those who do want to make money, much depends on detailed knowledge of the state of the market and the prospects of artists, hence the continued relevance of dealers.

Art, like all conspicuous consumption, blooms in glut and withers in straitened times. We have seen that the timespan we are considering here is bounded by two recessions, both exacerbated by wars against Iraq. The first recession was caused by the huge shakeout from 1980s glut, and led to the slaughter of many an art-world dinosaur. The vast (and vastly expensive) quasi-historical and neo-expressionist paintings by Anselm Keifer or Julian Schnabel that had been the perfect register of 1980s excess and bombast plunged in value, and swiftly disappeared from the salerooms (along with quite a few of the salerooms). Their reintroduction to the market some years later was so sensitive a matter that a critic I know wrote a catalogue essay on one of these giants for a commercial gallery with the dealer literally standing at his shoulder.

Developments in Japan were important to the speed and depth of the recession in the art market, particularly because of

the scale of Japanese buying throughout the 1980s, itself buoyed by apparently rampant and unstoppable growth in share and real-estate prices. The fall in prices was exacerbated by corruption. Peter Watson provides a detailed account of the scandal, in which works of art were used to launder huge slush funds to benefit corrupt politicians and organized crime: government curbs on profiting from real estate were stepped around by sellers 'buying' a painting on the understanding that it would soon be bought back from them at perhaps ten times the original price. The damaging thing here was not merely that secret deals were being made or tax evaded—standard characteristics of the Japanese art world—but that the scam distorted the market. Suddenly it seemed that the Japanese penchant for paying large amounts of money for undistinguished impressionist and post-impressionist paintings was less to do with naivety of taste than unscrupulous calculation. The breaking of the scandal had a depressing effect on the market, which was further shaken by prominent Japanese bankruptcies and the threat that large numbers of works bought at the height of the boom might be suddenly offloaded, further lowering prices. When some of the works involved in the scam were sold off in 1993, it was at a tiny fraction (under 1 per cent) of the prices originally paid.

These economic waves affect not merely the volume of art sold but its character. Painting, the most easily saleable form of art, undergoes a predictable revival with each boom, while less straightforwardly commercial practices—including performance and the various strands of post-conceptual art—step out into prominence with each bust. This is played out in a continuing struggle between the market and apparently unmarketable forms (credibility in eschewing overtly commodifiable forms may eventually lead to market advantage). It is a predictable and mechanical process. So, to take one example, economic revival in the US in the mid-1990s produced a concerted attack on the political art of the previous years, and a sustained attempt to rehabilitate beauty in art, and to establish the voice of the market as the final arbiter of taste (we will return to this in chapter 5).

Recovery from the fall of 1989 took several years, and many wondered whether the market would ever regain the heights of the 1980s boom. Japan remained sunk in recession or at best sluggish growth. While in the developed neoliberal economies, especially the US, economic growth was quite strong, elsewhere there was a series of catastrophes. Severe regional shocks that threatened global economic meltdown took place in Mexico (1994), Southeast Asia (1997), Russia (1998), and Argentina (2002). Perceptions of this period are thus extraordinarily diverse,

depending on where you are looking from. For much of the US it was a period of sustained growth and comparatively low unemployment. For the areas of regional crisis it was a time of economic catastrophe, often accompanied by social and political disturbances and environmental disasters. This dichotomy is clearly reflected in the different art produced out of each.

This is not to say that art in these troubled places simply reflected their national troubles. To take Mexico as an example: in the years after the North American Free Trade Agreement (NAFTA), which created a trading block of the US, Mexico, and Canada in 1992, the Mexican art that had the most success on the international market was ironic and depoliticized, despite the extraordinary depredations and revolutionary resistance in the country itself. Coco Fusco points to work by Gabriel Oroczco, Francis Alÿs, and Miguel Calderon as examples, describing the attempt to insert youngish conceptually inspired artists into the international market, in collaboration with US institutions. and so promote an updated image of Mexican culture. Cynthia MacMullin describes how this shift was led by Emilio Azcárraga, founder of Televisa, one of Mexico's most prominent producers of soap operas. In 1987 Azcárraga opened the Cultural Center for Contemporary Art in Mexico City where international artists were shown. Directed by US art historian Robert Littman, it mounted

new and sometimes controversial shows by Mexican and international artists until the death of Azcárraga in 1997. Televisa was associated with the PRI. Mexico's party of government for seventy years until its fall from power in 2000, and art and business interests were closely interconnected. International links, particularly to the US, were built through travelling exhibitions and cross-border art events. So, when Mexico underwent a severe economic crisis from 1994 onwards—plunging much of the population into penury and even starvation—the market for contemporary Mexican art, internationalized and tied to transnational corporations, sailed on regardless. Some of this work was not merely mild and disengaged but actively hostile to popular political engagement: Francis Alÿs' event and video Patriotic Stories (1997) had sheep driven in circles around the giant flagpole that stands at the centre of the Zocalo, the traditional site for political rallies in Mexico City.

As it grew, the 1990s bubble of stock market growth, associated especially with high-tech industries, had an inflationary effect on art prices. Record sums were achieved at auction throughout the late 1990s. When the bubble burst once more—following the dot.com share price collapse, accounting scandals (including that involving Enron), and the events of September 11—the art market and museums sector also went

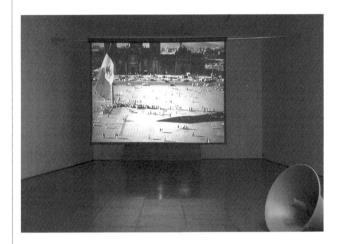

11 Francis Alÿs, Patriotic Stories.

in decline, and it is uncertain how long the market as a whole will retain its confidence, especially as Japanese corporations and museums finally begin unloading some of the art works they purchased at very high prices through the 1980s. The collapse of Enron is symptomatic of the links between the art market and the corporate world. The company's munificence, founded on fraud, floated the Houston art world. Enron had a reputation for taking economic risks, matched by an ambitious \$20m art programme which had been used to build an art collection more daring than the general run of corporate collecting. Their new Houston HQ was to be decorated with site-specific commissions from, among others, Olafur Eliasson and Bill Viola. As we have seen, the last recession caused a wave of extinction as the climate changed, with the death of many a US and German neoexpressionist beast. The new one, if sustained, is likely to do the same—and the prices of some artists, including Damien Hirst, have been in decline for some years. If long-term recession is in prospect, due in part to the vast scale and systematic character of US borrowing (increased by the Bush regime's tax cuts and huge military spending, and its effects on the world economy), then the entire character of the art market and its products will be once more thrown open to change.

The art market may be peculiar for buyers, but it is equally odd

for producers. According to Hans Abbing, its idiosyncrasies condemn the great majority of artists to penury. While the status of the profession is very high (in part because it pretends to stand apart from the regular run of commerce) and the incomes of the few successful artists are astronomic, the overall nature of the arts economy is generally disavowed by its participants, particularly artists, who overlook or deny their orientation towards financial reward. Artists are singularly ill-informed about their prospects for success, are prone to taking risks, are poor but come from wealthy backgrounds (an anomaly since most poor people have poor backgrounds, but one does not have to search far for the reason for it), and tend to subsidize their art-making out of other earnings. These factors, claim Abbing, cause the art world to be permanently overcrowded, making the poverty of artists a structural feature. (In the UK, the number of fine art students going to college each year has nearly tripled since 1981, far outstripping the general rise in student numbers.) Increasing subsidies would make matters worse, since it would merely encourage more to try their hand. What is more, the poverty of artists contributes to the status of the arts, for the few successes should be seen to be picked from a vast pool, and all artists should be seen to risk poverty in their pursuit of free expression.

Abbing says that features of this economy resemble the pre-

capitalist era—particularly the importance of gifts and patronage, and the role that personalities play in their granting. Other features, however, are more reminiscent of early capitalism, particularly the tiny proportion of successes to failures (p286). As a whole, the art market is an archaic, protected enclave, so far immune from the gales of neoliberal modernization that have swept aside so many other less commercial practices. Its status grants it social distinction and a degree of autonomy, even sometimes from the odd market that is its basis.

Art's autonomy

The autonomy of art has been powerfully described by the sociologist Niklas Luhmann, who compares it to other functional systems in modern society (such as science, politics, and law). It has the same tendency to 'operative closure', a drive to discover its own function and to focus on it alone. For Luhmann, art's exclusive feature is that it uses perceptions, not language, and is thus separated from mundane forms of communication. Its role may be to integrate the incommunicable into the communications networks of society. (We shall see later that as a description of recent art, at least, this account has to deal with the problem that the gap between the two seems to be lessening.)

For Luhmann, the more art tries to immerse itself in the general run of products and discourse in society—by for instance moving commercial products into the gallery and dubbing them 'art'—the more it ends up reinforcing its autonomy:

No ordinary object insists on being taken for an ordinary thing, but a work that does so betrays itself by this very effort. The function of art in such a case is to reproduce the difference of art. But the mere fact that art seeks to cancel this difference and fails in the effort to do so perhaps says more about art than could any excuse or critique (p. 145).

Yet the art system does have distinctive features: participation in it is optional (which can certainly not be said of economics or law), and it only inspires a low level of participation (a large proportion of the British population, for example, are not gallerygoers). Its means of inclusion and exclusion are independent of those of other systems, and it is a comparatively isolated field of activity (again, for example, the connection between politics and law is very close).

Luhmann's account is a systematic but ideal description that discounts the effects of class and distinction, and of market and state pressures on art. We can be more specific, for example, about who participates: Bourdieu and his collaborators' extensive sociological study *The Love of Art* examined the museum- and

gallery-going habits of Europeans, bringing out forcefully how much activity was determined by education. Simply, this educated people are more likely to go to galleries, feel more comfortable there, stay longer, and are more able to talk about what they have seen.

Nevertheless, Luhmann's book also fixes upon the actual autonomy of art, which paradoxically accounts for its connection with and use to other systems. That autonomy, far from being illusory, is central to art's ideological function, and is maintained by art's various institutions, including academia (art schools, art history and visual culture departments), museums, and professional bodies. The art promulgated there is sometimes at odds with that which achieves success in the market.

Howard Singerman's fine account of the development of art as a university discipline analyses the effects of this institutionalization on art's products. Universities work to separate professional artists from Sunday painters, and do not expect of art students that they be manually skilled, take recreational pleasure in their work, or wrench it from their tortured souls. Rather, they must produce a distinct and certifiable knowledge, in a theoretical and esoteric language, guaranteeing the exclusivity and status of the art profession. Artists are not only trained in universities but sometimes come to inhabit them—as part-time

teachers, or as touring performers accompanying their work. This escorted art may sell, but it achieves an independence from the commercial market, since in effect the artist's time is purchased rather than the work. It, too, achieves autonomy from the general run of mass culture, at the price of adapting to another set of institutional concerns, those of the increasingly audited and professionally administered university. This art of the academy which Singerman compellingly describes—comprising video, film, and performance—usually requires the presence of the artist at least for exposition, appeals to academic audiences, and is built on grants, fellowships, and residencies. Its main purpose is to generate dialogue among professionals, but the effects are far broader than that, influencing much of the discourse around art.

The first effect is that for there to be an art department there must be a unified and bounded thing, called 'art'. The second, that it can be researched, and that much of what artists do can be described as research. The third, that the field requires description in a specialized language, the acquisition of which securely identifies art professionals. All these effects tend to produce an art that talks most effectively to art insiders, and seals out the wider public.

This autonomy is not static, unitary, or unchallenged. The specialist world that serves the markets is guite different from

that connected to academia. To get a rough-and-ready understanding of this, contrast two prominent models—the magazine *Flash Art* (look at the quality of its paper and colour reproduction, the number and character of the adverts it carries, the accessible style of writing) to the journal *October*, with its restrained visual style, monochrome illustrations, complex, elevated prose, and arcane theoretical canon.

Furthermore, as we shall see, the professionalization to which academia aspires is directed against a populism encouraged by the state and—to a limited degree—by business. Highly trained museum professionals, who have spent years arduously acquiring specialist art-world discourse, are enjoined to lose it when communicating with the public. Displays in public spaces must be understood by the uninformed.

These tensions can be clearly seen in the discourse surrounding the highly successful work of Liam Gillick, much of it generated by the artist himself, though to get an understanding of it will require a short exploration of part of his work. The brightly coloured translucent screens and platforms of Gillick's Whitechapel Gallery exhibition, *The Wood Way*, appear to offer a corporatized version of the modernist architectural utopia in which the transparency of glass would bring light, health, mental clarity, openness, and nature itself into the gloomy domestic

I Jeff Koons, Loopy, 1999, oil on canvas, from the Easyfun series

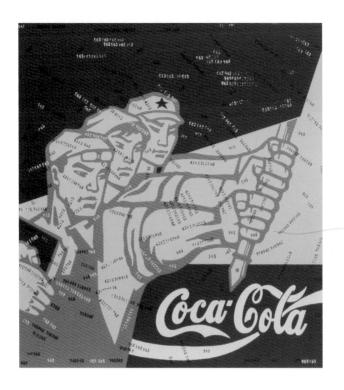

7 Sylvie Fleury, ELA 75/K, (Easy. Breezy. Beautiful.), 2000

interior. If that vision failed, it was, as Ernst Bloch strikingly puts it, because the plate glass window of the 1930s did not look out on anything delightful but rather on the capitalist world and fascism:

The wide window filled with a noisy outside world needs an outside full of attractive strangers, not full of Nazis; the glass door down to the floor really presupposes sunshine that looks in and comes in, not the Gestapo (p.187).

Gillick makes objects and exhibitions generated from short books that he writes, and *The Wood Way* was elaborated by using the text of his book *Literally No Place*, both meditating on the condition of utopian thinking and construction in what appears to be a definitively post-utopian time.

Gillick's work has long been concerned with the bureaucratic and technocratic middle ground in which most decisions are made—in the developed world, at least—by politicians, business people, planners, and administrators. Insistently, he asks an important question: how is the near future controlled in a postutopian situation? Lacking the old absolute goals of religious redemption, equality, or a cleansed and harmonious nation, what implicit vision drives the future onwards? In making objects, Gillick takes corporate material—colours, logos, typefaces—and sets them into aesthetic play. On the face of it, this is to take the

12 Liam Gillick, Renovation Proposal for Rooseum, Malmo.

His work deals with it in a number of ways. The most salient is a play with near-past and near-future, using a device that draws upon the thinking of Walter Benjamin, who similarly looked to recently outmoded and unfashionable commercial structures—the shopping arcades of Paris—for ideal architectural visions that prefigured the impending modernist and communist utopia. Gillick looks back to the commercial and administrative structures of another as-yet unrecuperated recent past, the 1970s, to make current ideological and aesthetic structures visible and strange.

Another way is in an attack on humanism: in *Literally No Place*, Gillick goes as far as to say that utopianism is a critique of humanistic thinking. Gillick's aesthetic play, while appearing to offer the chance for democratic participation, engagement, and dialogue, often frustrates those expectations, with fixed arrangements of tables and chairs that are awkward and unlikely to promote exchange, with a catalogue for an exhibition placed out of reach of the audience, with a fake manuscript of blank pages, and in general with arrangements that—despite their cheery corporate colours—seem alienating and rebarbative. Thus the function of bureaucracy, the inhuman management of human beings, is cunningly revealed. The gallery and the museum, ever more manifestly the servants of the corporations, are a salient place to stage that revelation, though the status of

the works themselves—as an exemplification of that condition as much as a rejection of it—remains deeply ambivalent.

Gillick is an artist who offers possibilities rather than holds a position, and who wants his work to be 'in a constant flux between perception states, like a flickering sense of function, ideology and art'. In this he adopts conventional art-world tactics. Writing of *The Wood Way*, the curator Iwona Blazwick claimed that Gillick: 'has created opportunities for us to meet, to reclaim the idea of discussion, consultation, renovation, or delay—for us to become protagonists in modelling possible futures' (p.5).

It is the undefined 'us' in this statement that makes it contentious; Gillick's practice does seem to have offered just such opportunities for a small and elite band of collaborators, curators, and collectors—and wider groups of gallery-goers have used his spaces for various forms of play or discussion. Yet the barriers to such participation seem high, and perhaps the very character of exclusiveness, distinction, and hierarchy confers on his objects and texts the allure that brings to them their homogeneous cultural club.

Gillick's work exemptifies some of the tensions between art's professional discourse and its wider functions and ideals. If professionalization is pushed too far, that would again undermine art's claims to universality (and thus the reasons for its

protection). If accessibility and instrumentality were pushed too far, art's distinctness from the rest of the culture would erode with similar results.

Besides these general tensions between different models of autonomy—brought into existence by the market, the university, and the museum—there are more specific recent forces that threaten to dissolve the fabric of art's autonomy: the modernization of the art market, and the competing claims that art should be useful, promulgated by the state and business.

Modernization?

There are some signs that the art world is having modernization thrust upon it by economic and technological change.

Technological innovation has been a continual threat to art's protected enclave. Photography was only assimilated by emphasizing the manual craft of producing the print, and through other tactics that withdrew the sting of reproducibility, such as the use of Polaroids (which are unique, single prints) and more recently (as we have seen) the inflation of prints to a size that suits the museum. Video was more recently assimilated by downplaying its utopian social criticism and aspirations to wide participation and distribution in favour of splicing it with installation to make comforting, museum-based objects

reminiscent of painting or sculpture.

A more recent and fundamental challenge is Internet art. From the mid-1990s onwards artists started to use the Web to make works not merely reproducible but freely distributable. Such works can be copied perfectly from one machine to the next, and much of the code that makes them operate is open for viewing, copying, and rewriting. If the Net culture of sharing data threatens even those industries that have embraced industrial production methods how much worse it looks for those that have not. Ownership in such circumstances means little. particularly because the ethos of Internet art tends to be more about dialogue than the production of finished works, let alone objects. Internet art does not challenge the production, ownership, and sale of art objects themselves, but it opens up a new realm in which artists produce immaterial works that can be viewed as art, and which can be free of dealers and the agendas of state institutions and corporations. People who want an experience of art, or who want to make and curate it, can do so directly. The effect has been extraordinary, and we will return to it in the last chapter.

Another sign of modernization is the move of the major auction houses, which have become publicly owned companies and so legally committed to maximizing profits, into the area of

contemporary art. They have produced exhibitions, curated by respected figures and accompanied by weighty catalogues, as a way to bolster contemporary work that later comes up for sale. They have also emulated artist-run 'alternative' spaces by installing shows in disused industrial buildings, and have even purchased dealerships. These moves have been successful, in part because artists see an advantage in breaking the monopoly of the dealers. Since at least the 1980s, contemporary art has sold profitably at auction, and the very existence of this 'secondary' market undercuts the monopoly of the dealers, particularly since it involves less control of consumption.

This has been in response to, and has also helped to create, the rise of a type of dealer-collector, who buys for speculative investment, often outside the usual run of galleries—through auction or from other collectors. In the UK, Charles Saatchi is the most obvious example of this type, since he deals in art for speculative purposes and his art collection is linked with his corporate finances. He is well known for buying directly from artists or even degree shows. The result of such activity, as Timothy Cone argues, is that galleries have less control over artists' prices, and have to respond to their artist's positions in the secondary market. Nevertheless, Cone goes on to say that much price-fixing and lack of transparency still exists. Auctions fix prices

for artists' work and are frequently manipulated by collectors or dealers paying over the odds to push up the value of their holdings. In the art world, these practices of price-fixing and insider trading, which would be illegal in any other realm of investment, remain commonplace.

Another factor that has greatly affected the market is corporate collecting. This is a fairly recent phenomenon, the vast majority of such collections being founded after 1945, and most since 1975. Some of the consequences for the trajectory of contemporary art are laid out for an earlier period by Alexander Alberro in his remarkable book about the marketing of conceptual art at a time when corporate collecting was first becoming important. Corporations collected innovative art that would favourably reflect their own values of creativity and entrepreneurialism. While it had been a minor activity, separate from the general running of a business and often dependent on the interests and tastes of individual executives, corporate collecting has lately changed. Among large corporations, collecting is integrated into the business plan and is designed to be congruent with the company image. It has become thoroughly professionalized, and is no longer geared merely to finding something decorative to hang on office walls. Nevertheless, Chin-tao Wu's account of corporate collecting

argues that there is still a preference among businesses for flat, decorative works that do not risk controversy over social, political, or religious issues. These works, after all, are intended to be seen in a setting that is neither fully private nor public. Generally, corporations make sure that their collecting and sponsorship programmes support each other, that the whole serves to reinforce the brands being promoted, and that employees are involved and stimulated by the art they have to work alongside. Furthermore, the rhetoric of business creativity is now taken so literally that some companies use art to encourage original thinking in their workers.

It is difficult to assess the impact of corporate collecting on the contemporary art because most dealings remain secret. We can guess that corporate art collecting accounts for a considerable volume of contemporary art sales, but it is hard to know just how much because art-buying is often included in public relations, building, or furnishings budgets. Wu cites a 1990 study that claimed that in the US about 20 to 30 per cent of art sales in New York were due to corporate collecting, and about half outside the city. It is likely that the sheer volume of this instrumental, institutional buying makes the art market behave more like a normal market.

Abbing argues that there are signs that the exceptional

character of the art economy is on the decline. One is the increase in the status of applied art (a prominent example being fashion photography). As we have seen, this is a limited phenomenon, and as much to do with mass culture borrowing art's kudos through gallery display and all the usual surrounding apparatus as of any admittission that other areas are art's equal. Another sign is the increasingly ambiguous attitude of artists to art's status, and an increase in unveiled economic activity. According to this view, artists who satirize the pretensions of the art world (such as the now disbanded London-based collective Bank) and those who nakedly pursue enrichment (like Koons, Murakami, or Hirst) may both be seen as signs that the high status of art, and its apparent separation from vulgar commerce. are no longer secure. It is, however, unclear whether these features are more structural than cyclical, and tied to the rise and fall of the market. It is easy, after all, to point to previous examples of both types of artist (Art and Language and Warhol respectively quickly come to mind).

Uses of art

There are more fundamental challenges to art's autonomy of apparent uselessness than these elements of modernization. The supplementary character of art to neoliberalism is becoming

more visible as both corporations and states, aware of the lack in free trade, attempt to augment it by making instrumental demands on art. Corporations want to use art to assure an attachment to the brand that cannot be purchased by advertising; the state wants to counter the destructive effects of free trade on social cohesion. Both, then, are attempting to counter the very forces that they jointly set in train. Naomi Klein has argued that it was deindustrialization in the West (the 'outsourcing' of production to developing countries) that broke the link between communities that made and bought consumer goods. This led companies to place ever greater emphasis on the logo and the brand, and eventually triggered a political reaction against them. As part of this obsession with brand image, corporate demands on art have become more widespread and systematic. Even rich states face the social breakdown caused by the same forces that make inequality ever greater and sunder any perceived link between production and consumption, driving many into penury and insecurity, and pressing even on the middle classes that sustain the whole system of consumerism.

Business has moved from occasional charitable sponsorship of the arts to building partnerships with museums or artists in which the brand of one is linked with the brand of the other in an attempt to inflate both. They have further turned increasingly to collecting and commissioning art, exhibiting it, and recently even into curating exhibitions held in public venues.

A telling example of such an alliance has been Selfridges' engagement with art in recent years, examined by Neil Cummings and Marysia Lewandowska as part of their project *The Value of Things*. The department store sponsored a show called *The Warhol Look* at the Barbican Gallery in 1998, taking the opportunity to dress their windows in a 'Factory' theme, and to stage a Warhol-inspired fashion shoot. The Food Hall predictably contained stacks of Campbell's soup cans, Brillo boxes, and Coca-Cola bottles, alongside Warhol prints, and there were screenings of Warhol films along with suitable promotions in the menswear department. Warhol, of course, begs for just this treatment, but this was only the start of a set of strategic moves by Selfridges to exploit the contemporary art world to gain custom.

Another example is the series of Absolut adverts, paintings or objects reproduced as magazine pages, which forge a brand alliance between artist and vodka company. It was fittingly initiated by Warhol in 1985. These pieces, which make the relation between artist and corporation particularly transparent, have continued into the present; many prominent artists, including Keith Haring, David Levinthal, Ed Ruscha, and Vik Muniz have

made them. Similarly, Takeshi Murakami, an artist who openly strives for commercial success, has allied himself with Louis Vuitton, designing bags which have sold very well, and recently producing a promotional art video for the fashion house. This video, Superflat Monogram, is an entertaining update of Alice in Wonderland, in which a girl, searching for her lost mobile phone, floats in a dizzying world of the company's logos. It is a thoroughly hybrid item, being both elongated advertisement and an animation in Murakami's signature style. It was shown in the first room of Francesco Bonami's painting exhibition for the Venice Biennale in 2003, and also at Louis Vuitton's flagship stores worldwide, to further boost the sale of Murakami handbags.

Until recently, corporate involvement in the arts was a murky area, shrouded in confidentiality agreements and intermittently illuminated with the bright flashes of celebrated and censored works by Hans Haacke that examined the corrupt dealings of art sponsors or the business activities of museum board members. We are now fortunate to have two major, detailed accounts of corporate engagement in the arts by Chin-tao Wu and Mark Rectanus, both of whom have had to write their work in the face of the secrecy that surrounds the subject. Neither the arts institutions nor the sponsoring corporations are anxious to reveal the details of their arrangements with one another.

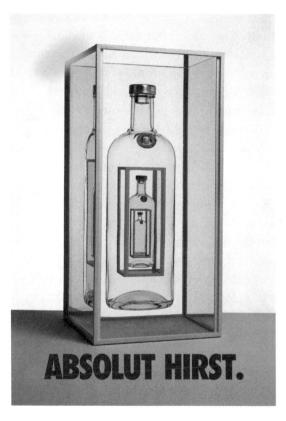

13 Damien Hirst, Absolut Hirst.

Wu's account focuses on neoliberal states, the UK, and the US. It charts the privatization of art, particularly in the UK, where state funds were withdrawn from museums and other arts institutions; in both places corporations moved into sponsorship, commissioning, collecting, and publicly displaying their collections. In the UK it was the explicit aim of the Conservative government led by Margaret Thatcher to transform the uncomfortably political character of contemporary art by making it more reliant on market forces. Likewise, Ronald Reagan personally supported corporate involvement in the arts from, among others, oil and tobacco companies.

Sponsorship and other longer-term deals with art institutions have obvious and quantifiable benefits for corporations. There is an appeal to potential customers who are otherwise hard to reach: art audiences are richer and better educated on average than the general public, and are thus highly valued by companies. There is the further benefit that comes from seeming to be charitable. Many companies that sponsor the arts have image problems, and seek to burnish their reputations with cultural munificence. This is the case, for example, with BP's long alliance with the Tate. Similarly, the German tobacco company Reemstma sponsored Documenta IX to promote West cigarettes through limited-edition posters and packs; examples appear in

the back of the catalogue to the event. Large-scale arts sponsorship can also be used for political leverage. Wu gives a striking account of the machinations of the cigarette company, Philip Morris, a major sponsor of the arts in the US, which opposed—unsuccessfully, as it turned out—proposed antismoking legislation in New York by threatening to withdraw all its arts support from the city.

As both Wu and Rectanus point out, companies get a lot for their money. Since they sponsor exhibitions—and now as much as 70 per cent of exhibition costs in Europe come from private sources—they get maximum publicity associated with these events. Funding of the rest—the unglamorous matters that range from cataloguing collections to maintaining the drains—falls to the state, which provides a subsidized infrastructure on which the limited largesse of the corporations depends.

All this affects the culture directly. Corporations have specific demands which must be met before they will sponsor. Projects that fail to meet them have little chance of being seen, certainly not in the prominent institutions that rely on corporate deals. Rectanus says that the main criteria are whether the area of cultural activity corresponds to the company's core markets (Nike are unlikely to sponsor an exhibition by Rembrandt), whether the show is likely to get good media coverage, and whether the

Uses and prices of art

individuals or groups involved are suitable subjects for promotion.

The results have already been examined in the previous chapter: an emphasis on the image of youth, the prevalence of work that reproduces well on magazine pages, and the rise of the celebrity artist; work that cosies up to commodity culture and the fashion industry, and serves as accessible honey pots to sponsors; and a lack of critique, except in defined and controlled circumstances. Indeed, the recently renewed prominence of Hans Haacke is an example: this venerable figure from conceptual art's radical political past has been paraded in the mid-1990s as an archaeological curiosity, isolated, and bearing with him (undoubtedly against his intentions) a heavy whiff of safe and powerless nostalgia.

Sponsorship also tends to produce spectacular, costly works, in which expense is a manifest quality. This conspicuous consumption simultaneously validates artist, museum, and sponsor, and is another force driving large-scale installation, video, and other high-tech displays. Furthermore, when large corporations sponsor or make alliances with an art institution, they expect—given their own global reach and expectation of economies of scale—to engage with an international if not global culture. This is another regular pressure on art bodies to

hybridize their displays.

Aside from these immediately commercial concerns, corporations have been involving themselves in programmes that widen access to the arts, or link it to progressive social causes. Their involvement in such causes produces a double effect: it draws in a diverse or disadvantaged audience, partly in the hope that upward mobility may produce future consumers; mostly it assures the elite audience for art that they are seeing not merely aesthetic sweeties (the consumption of which is sometimes haunted by guilt) but also phenomena of worthy social significance.

Corporations wish to elevate themselves by association with that which they cannot embody, including the free play of high art. As the now notorious Philip Morris slogan says: 'It takes art to make a company great.' At the same time, as we have seen, corporations strive to be creative and cultural. Rectanus says that corporate-speak about the arts serves to legitimize the company as having creativity, being a patron, dealer, or at least broker and collector, and as an integral part of the art audience, the community to which the arts should appeal (p.73). If art helps corporations in these image-improving activities that increase profits, the risk is that if the process becomes too transparent art ceases to be imbued with the very autonomy that gives it the

Uses and prices of art

status to act in this way.

Recent state demands on art complement those of the corporations, for both have similar interests in fostering social quietude, cohesion, and deference in the face of the gale of creative destruction that the economic system they are committed to propagating continually gives rise. In Britain the Labour government sees art as a way to boost the economy, particularly in the so-called 'creative industries', as an aid to regional development, and as a social balm to heal the divisive social rifts opened up by the long years of Conservative rule. Art should be of quality without being elitist, and should draw in new, diverse audiences. There are similar moves in the US, where National Endowment for the Arts (NEA) funding, long under successful attack from conservative politicians, is newly justified on the grounds that art has a role to play in social programmes, including crime reduction, housing, and schooling. The danger of such moves—highlighted in a survey of attitudes entitled Art for All (edited by Mark Wallinger and Mary Warnock), in which there is much moaning about state direction of the arts—is that in revealing the instrumentality of art, they also unmask with too much clarity the relationship between art and the state, which is supposed, after all, to be founded on idealism and eternal human values. If states fund the arts to improve the souls of their citizens, the effect is ruined if those consumers of art wander about galleries thinking about advertising strategies and regional development. Increasingly, those thoughts are unavoidable. Art can only meet the instrumental demands of business and state if its function is concealed by the ideal of freedom, and its qualitative separation from free trade is faithfully sustained.

The state and business are happy to leave art beyond the reach of pure profit maximization. In many nations the state plays a large role in hoarding and displaying art objects, influencing the determination of taste and the course of art writing. If art works were truly commodities like any other, states should be content to leave their purchase, conservation, and disposal to market forces. While commodities are thought to divide as well as define identity, appealing to competing impulses within the individual, there is a presumption that the art work within the museum forges social cohesion even as it celebrates difference, and reinforces collective memory even as it recycles and recombines diverse and disparate references.

We have already described some state motives for supporting the arts. They can play an important role in regional development or the regeneration of a city. The supposedly universal character of the arts serves as a mask for its various uses. Critique can rebound to the honour of whoever gives it a home. Nevertheless,

Uses and prices of art

there are very marked differences between models of state funding, even among wealthy nations. For example, in Germany, decentralized arts funding reflects postwar arrangements supposed to prevent any recurrence of nationwide propaganda programmes. Rectanus writes that while German funding for the arts has been generous—and channelled through city, town, and regional government bodies (the Länder)—in the 1990s, budget cuts following reunification produced an emphasis on mixed funding that sought to bring in private money to complement government funds. In addition the privatization of German state companies, European integration, and the globalization pursued by media conglomerates has tended to militate against such local arrangements. With the reunification of Germany, and the move of the capital to Berlin, modest centralized state funding of the arts has been established.

In marked contrast, the NEA budget in the US, always modest, was cut back following political assault by the Right: it stood at \$80m in 2000. Rectanus contrasts this sum with a *single* sponsorship fund, given by Intel to the Whitney for their 1998 show, *The American Century*: admittedly, the largest ever granted to a show, it was \$6m. Tax relief on donations to the arts (from individuals, charities, and corporations) brings in about \$2bn a year. A similar sum is spent on the arts per head in France or

Germany, but because it comes from private sources, in the US it yields very different results.

The growth of museums and museum expansions worldwide through the 1990s was without precedent—among the many examples of new museums are Tate Modern, the Houston Museum of Fine Arts, the Chicago Museum of Contemporary Art, and the Guggenheim in Bilbao. Adrian Ellis has cogently outlined some of the possible causes. First, museums have always been a way of expressing the prestige conferred by wealth, and in the 1990s that wealth became further concentrated—so the rich do what they have always done, but they are richer now. Secondly, national and regional competition plays a role, which we have already looked at. Thirdly, new education and entertainment programmes in museums need more space. Fourthly, changing leisure patterns mean more museum-going, Lastly, expansion introduces competition between museums themselves, so that staying the same while all around are growing does not seem an attractive option. Ellis goes on to argue that, given the continually under-capitalized state of museums which makes it hard for them to maintain buildings and retain staff, this expansion is often resorted to out of weakness. Museums are reliant on generally shrinking subsidies from the state, and sponsorship or other arrangements with patrons and business. The most popular

Uses and prices of art

ways to recapitalize are putting on blockbuster shows and going for expansion. It is far easier to get private funding for glamorous expansion projects than for subsidizing the regular running of a museum. The difficulty with expansion is that in the long term, unless the programme has been so successful that it has generated numerous further funding opportunities, it exacerbates the underlying problem, leaving the museum with larger buildings to light, heat, staff, and maintain. The 1990s economic boom fuelled much expansion, as the rapid rise in the stock market both directly and indirectly made museums richer. The recent recession has brought a dramatic halt to many programmes, including those at the Los Angeles County Museum of Art and the Whitney, among others, and the closure of two branches of the Guggenheim, in the SoHo area of New York and in Las Vegas.

An effect of this extraordinary expansion is, plainly, to stimulate the production of art. As Howard Becker points out, we never come across empty galleries for lack of sufficiently good art to display, so both standards of judgement and quantity of output must be elastic enough to fill them. This has no doubt been another stimulus in widening the global reach of contemporary art, a key way of expanding the ambit of production.

Given this increased competition, museums have branded

themselves. The most signal example here is the Guggenheim operation, a global museum franchise, and its most evident manifestation is the Guggenheim Bilbao. Under the directorship of Thomas Krens, the Guggenheim has expanded with new spaces in Venice and Berlin in alliance with Deutsche Bank, and (as we have seen) two further branches that were to become casualties of the recession. The most daring venture was in Bilbao, a once wealthy industrial city far from the tourist trail, divided by separatist politics, including the ETA bombings and assassinations. In Kim Bradley's detailed account, the museum was tied to the development of the city's port, new subway and airport, and above all to the retail, office, and residential waterfront development of which it was a part. It has certainly been an extraordinary success in turning Bilbao into a tourist destination, branding the city with Frank Gehry's bravura sculptural building, clad in titanium. The regional government paid a heavy price, covering all the Guggenheim's costs to conceive, design, build, and run the space. A \$50m acquisition fund was established, though the works purchased would remain property of the Guggenheim. On top of this, there was a \$20m tax-free fee for loan access to the rest of Guggenheim collection and for the use of the brand name. The museum has been marketed mostly at foreign tourists, and the extent to which it

Uses and prices of art

would engage with Basque interests was hotly debated in its early years. Its purchases and shows, despite another large sum of money granted by the regional government for the development of a Spanish and Basque collection, have been of well-known US and European 'masters'. We have seen that installation art ensures attendance from a committed art audience. Architectural extravagance can do the same, and the two regularly come into symbiosis, as installation responds to its setting.

More broadly, for an arts organization, the Guggenheim is a particularly transparent business enterprise, its exhibitions bent to its financial interests. *The Art of the Motorcycle* commenced a number of shows that seemed to be more opportunities for sponsors than displays of culture. *Giorgio Armani*, held at the NY Guggenheim in 2000, was a puff piece that, it was suspected, had some relation to Armani's \$15m sponsorship deal with the museum. The show was more a display of currently available merchandise than a historical survey of the fashion house's products, and neither the display nor the catalogue did more than simply celebrate Armani's designs. Armani had, in effect, hired the museum to display an advert.

The Guggenheim enterprises point to broader trends.

Branding in the art world has flourished. Galleries and museums

burnish their new logos, striving to impress the character of their brand upon the public. The branding of 'Tate' (marketers conduct systematic warfare against definite and indefinite articles) has produced an entity that exceeds its various physical branches. and achieves cross-branding symbiosis through deals to endorse, for example, a range of household paints sold at DIY giant B&Q. Many artists similarly strive to achieve brand recognition, and a few succeed: Tracey Emin has become a brand out of which her art is made. Such artists as brands are again allegorical figures that, like robots, deliver particular and predictable behaviour along with other outputs. At a meeting on arts sponsorship held at the Royal Society for the Arts in 2001, a representative of Selfridges put the matter with candour: the display of Sam Taylor-Wood pictures across the façade of the shop during its refurbishment was a bringing together of two brands, to the benefit of both

We have seen that corporate sponsorship of exhibitions tends to militate against critical or radical content. The branding of museums is a still more effective force in silencing critical thought. If the building which houses the works has become an exceptional logo (its shape reproduced on carrier bags and museum-shop trinkets), and if the museum has expensively created a marketing style for itself of specific hues, fonts, and

Uses and prices of art

images that make up the brand identity, so the museum's contents are implicitly branded too, even by the labelling and interpretative material. The tendency is to produce shows that parade one thing after another with equal recommendation, as if art works never contend with or contradict one another. A blanket of assurance is thrown over the contents, branded by their very inclusion.

As art galleries and museums absorbed business practice and searched for larger and more diverse audiences, their character changed. Here is Bourdieu in *The Love of Art* on the still unchanged European museum of the late 1960s, imposing on its viewers the idea that what they experience there is utterly different from everyday life:

... the untouchability of objects, the religious silence which imposes itself on visitors, the puritan asceticism of the amenities, always sparse and rather uncomfortable, the quasi-systematic absence of any information, the grandiose solemnity of décor and decorum ... (p. 112)

It is enough to visit Tate Modern to realize how much has changed: architectural drama still serves to impress on the viewer the importance of what they are seeing, but the result is hardly solemn. The galleries, which play second-fiddle to extensive amenities and circulation spaces, are thronged with people, who

are happy to raise their voices, information is plentiful and there are some areas, at least, where interaction is encouraged.

The provision of clear information is the indicator of most important accessibility: as Bourdieu says, it tells the visitor they have the right to be there, even if they know little about the arts (p. 49). Equally, such information is very unevenly provided, and this speaks of the audience expected and courted. In major public museums there is a usually a good deal; in private galleries little; in many 'alternative' contemporary art events and in the biennales little or none.

These changes were part of the opening up of the art enclave to the processes of commodity display. Two of the trends we have looked at in this chapter push in opposite directions: accessibility and more standard forms of commodification towards at least partial mergence with commercial culture; academic professionalization of art towards autonomy and elite discourse. The contradiction is mitigated through the action of the state, because the very purpose of professionalism, at least in the museum, has been effective public communication.

There are areas where state and corporate uses of art come into greater tension. The state seeks to counter the hollowing out of democracy and the decline of sociability caused by unrestrained consumerism—the very result of the corporations'

Uses and prices of art

actions. The corporations' main purpose (aside from the propaganda function) is to sell goods to an increasingly cynical public, suspicious of conventional marketing methods. The direction of state policy is towards social inclusion and a broadening of the art audience. The interest of corporations lies in art's very exclusivity and association with elites and celebrities, a privileged realm that confers upon them the sanction of high culture and access to continued media coverage and profits. The more transparent that relationship becomes, the more art is tainted by it, appearing to be just another part of the general run of mass culture with its wearying apparatus of publicity and celebrity. No doubt the intention of having Madonna announce the Tate's Turner Prize in 2001 was to raise the profile of the event even further, while likewise elevating the pop star by association with high culture. The effect, though, was that every viewer knew just where they were, in the utterly familiar domain of mass culture, and the art displayed took on the role of more or less interesting diversions to the main spectacle of the star's publicityhungry misbehaviour.

The branding wars of the 1990s made art a more important element in the management of commercial images. This demotion of art's status can only continue, for corporations that care about their public image or are involved in the 'cultural

industries' cannot leave the advantage of participating in the arts to their competitors. Systematically, there is nothing that corporations can do but continue to undermine art's autonomy, the very basis of its attraction.

The fundamental contradiction is that fine art, from its archaic and protected enclave, propagandizes the very forces of neoliberalism that if applied to art would lead to its destruction. Benjamin Buchloh notes that the model of culture to which states subscribe has become corporatized, and that corporations want to reduce aesthetic experience to fashion; this model, he writes, is profoundly at odds with a democratic ideal of culture in which the public defines and comes to see itself. The ghosts of those ideals still cling to the arts (and are played upon by artists such as Gillick). They remain central to many people's views of art, no matter how regularly their expectations are left unmet. This issue is the key to opposing the use of art as a servant of business and the state, and we will return to it in the final chapter.

It is a basic art-world orthodoxy, echoed just about everywhere, that contemporary art is ungraspably complex and diverse. The variety of contemporary forms, techniques, and subject-matter in art is indeed bewildering. The conventional media of painting, sculpture, and print-making have been overlaid with installation and 'new media', which can encompass anything from online art to computer-controlled sound environments. Artists cultivate for themselves images that range from traditional guru or shaman roles to beady-eyed, tongue-in-cheek chancer and careerist, and personas that include star-struck adolescent girls and engorged, axe-wielding psychotics. Art's concerns are also various, touching upon feminism, identity politics, mass culture, shopping, and trauma. So it should not be surprising that art's ungraspable character is a staple of art writing by critics, curators, and publicists. Maybe art's fundamental condition is to be unknowable (that concepts embodied in visual form can encompass contradiction), or such statements may be part of an ideological outlook that conceals uniformity.

There are several reasons to suspect that the conventional views conceal something. Firstly, most art is instantly recognizable to both novices and the informed, and not just because it is on display in the gallery. Secondly, total randomness is one form of total uniformity. Thirdly (in tension with the second thought), as

we have seen, permissiveness is far from total, and much cultural production is systematically excluded from the contemporary art world. Fourthly, each element of art's variety is hybridized with others in a process that leads to a wider uniformity. Finally, there is so much current work that (like advertising) uses visual signs in a highly conventional manner. So perhaps art's knowability is on the increase, alongside statements boasting its essential unknowability.

There can, of course, be no pretence to scientific objectivity in any account of art. No such analysis can be objective in the way that, say, the examination of beetles can, since any account has some effect over the very scene that it surveys. The wide influence of Greenberg's sweeping account of the development of modern art as a Hegelian progress towards formal abstraction helped stimulate Pop Art, its explicit refutation.

Since the rise of the avant-garde, only art viewed from a historical distance has appeared to have direction and coherence, while the present always seems clouded in confusion. This loss of the orientation that we appear to have when looking at current art is a long-established feeling. In fact, those writers who, for better or worse, grasped without ambiguity an impetus in the present (such as Greenberg) have been the exceptions. Perhaps the historical mode of viewing art simplifies what we

see, reducing it to what is of interest to the present; but perhaps this is simply the necessary task of intellectual work in which diverse phenomena must be ordered, placed in hierarchies of importance, and much ignored or forgotten, to achieve a meaningful perspective on a scene. It is evident through our own period, as the art of what was once thought of as the global periphery travelled to the centre of art-world attention.

Art in the 1990s has sometimes been thought of as a synthesis between grandiose and spectacular 1980s art with the techniques and some of the concerns of conceptual art. The result was to splice linguistic and conceptual play with visually impressive objects. Tobias Rehberger's Seven Ends of the World, to take a single example, fills a room with clusters of glass balloons that glow with different coloured lights in a beautiful, slowly changing display; the lights in the balloons are renditions of local light conditions in various places around the world, relayed over the Internet. The piece is both a technically accomplished, spectacular and appealing object, and the manifestation of an idea.

Perhaps this synthesis is the result of a negative dialectic, which has forced on art not a realization but rather a taming of Conceptualism's radical critique, in a false accommodation with what it most despised. This is certainly the meaning of an

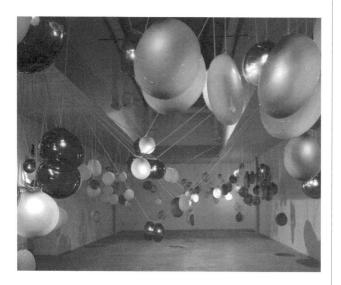

14 Tobias Rehberger Seven Ends of the World.

installation by veteran conceptual artists Art and Language at the Lisson Gallery in 2002. Here they remade their famous *Index* work—originally a piece meant to encourage interaction and dialogue—as a candy-coloured functionless sculpture, juxtaposed with a nonsensical pornographic text—a reference to the antics of 'young British artists'. From the point of view of the dealers, however, as Alexander Alberro argues, from the very beginning conceptualism carried with it the elements of that accommodation.

In any case, a spectrum of art lies along the line of the varying elements of this synthesis. One end—the most conventional and the most likely to be associated with unreconstructed notions of male genius—mixes the barest elements of a conceptual framework with large quantities of emotion, spirituality, or humanism to warrant the production of epic works—we might think here of Bill Viola, Anish Kapoor, or Antony Gormley, and (most recently) Matthew Barney. At the other end—and this is now a far commoner practice, as we have seen—concepts drive the production of objects in materials or media that are selected to suit them. Both ends react against the pervasiveness of the mass media: the first presents the viewer with a sublime or imposing spectacle featuring massive amounts of material or (latterly) data; in performance, the body and sometimes blood of

the artist form an assurance of organic and unique presence, as against all that is copied and transmitted. At the other end, mundane elements of the environment or the media are pitched into non-instrumental play: this can be seen clearly in works that take mass-media spectacle and simply remove the spectacle, a plain example being Paul Pfeiffer's digital alteration of the film of the Ali–Foreman boxing match, 'Rumble in the Jungle', to remove the boxers. Indeed, a defining feature of art since the end of cold war has been this play with borrowed images, material, and media, which has whittled away at deep, serious art of genius until its practitioners, now few, appear as eccentric survivals of a previous age, while traditionalists can only wail at the blanket dominance of 'conceptualism' and 'installation'.

What characterizes this new production most is the movement of ready-made objects (or at least readily recognized objects) and signs from one place to another, and their assemblage in novel reconfigurations. To start with some simple examples which come close to puns, take various instances of gilding: Cerith Wyn Evans' golden crash barrier elides ideas of money and control, and produces a striking hybrid object; Sylvie Fleury, as we have seen, does the same for shopping trolleys; Paola Pivi has gilded a jet fighter and, in an added element, displayed it upside-down. Or to take another frequently used

15 Paul Pfeiffer, The Long Count (Rumble in the Jungle).

16 Paola Piri, Untitled (aeroplane).

example, think of artists' treatment of that most valued of consumer objects, the car: there is Orozco's famous *La DS* (1993), a Citroën DS cut lengthways, a portion taken out of the middle, then stuck back together to make a slimmed-down version; or Gabinete Ordo Amoris' elongated Lada taxi (three have been welded into one) to make a Cuban taxi-limousine, commenting prettily on the peculiarities of the rise of the nouveaux riches on the island; or Damián Ortega's exploded Volkswagen, its component parts hanging like a 3-D diagram of a kit-assembly of the car on wires. (There are plenty of other examples, from Rehberger, Fleury, Charles Ray, and others.) These movable elements may be qualities as well as things: we can think of Orozco's *Oval Billiard Table* (1996), or Maurizio Cattelan's *Stadium* (1991), an elongated table football game that can be played by 22 people at once.

More generally, a vast range of art has been produced that contains such simple combinations of elements. To survey a large number of these is to have the (illusory) impression of an artworld machine that takes elements out of their functional place in the world and recycles and recombines them, so that, taken as a whole, any combination of signs and objects will eventually be arrived at. Displacement is a key technique of advertising, like art, which must shock and amuse or at least interest the viewer; use

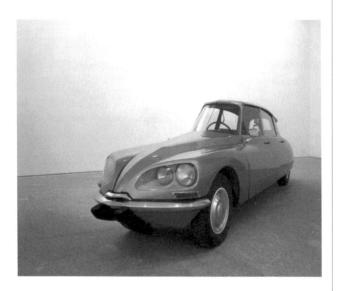

and placement are the main elements that separate art and advertising, which otherwise remain close and engage in frequent theft from one another.

There is a structural reason for this systematic exploration of such combinations as artists compete to find a distinctive place within the art world. As Howard Singerman puts it: 'The [art] student's task, like that of his works, is to take—and to mark—his or her place.' (p. 186) As more and more positions are filled, it seems as if no bringing together of elements is taboo. An extreme case is Zbigniev Libera's Lego (1996), a series of concentration camps built with the children's building blocks, which along with other similarly provocative works about the Holocaust were displayed at the Jewish Museum in New York in a show called Mirroring Evil in 2002 (see colour plate 8). The show was condemned in much of the mainstream press but was defended by liberal academics. Seen from the point of view of each artist's individual projects such pieces are various, distinct, and personal, and each may have a particular meaning. Seen from the point of view of the art-world as a system, they appear as the component parts of a uniform machine, which produces a large range of novel combinations that are tested against various publics for marketable meaning.

Lest Hume's point—that all human imagination is nothing

more than the combination of found elements—be thought to apply here, it should be said that, in comparison with modern and even many postmodern practices, these combinations have become simpler, their elements more manifestly found, their recombination more promiscuous and arbitrary, and the meanings that they generate more fleeting and cursory. For Paul Virilio, in recent lectures published as *Art and Fear*, in contemporary art the focus on the present, the obliteration of the past, and the type of sign-swapping encouraged by digitization are closely linked. We will return to this point in the next chapter, but perhaps there is a relation between the rapid play of images and the development of free trade, the erosion of barriers, historical memory, and identities in favour of the fungibility and mobility of objects, signs, and bodies.

This link with capital is generally disavowed in favour of another, more congenial reading: while in the past stylistic contradiction or inconsistency was seen by art historians as the unconscious expression of social contradictions (the locus classicus here is Meyer Schapiro's analysis of the sculptures at Souillac), now a fully conscious enactment of these inconsistencies is used to highlight an awareness of contemporary cultural decadence. Naturally, that very awareness and its parading in works of art allows viewers to enjoy the

spectacle of decadence, and assure them that mere awareness of it is sufficient to bear them to a loftier plane.

This uniformity in art-making is reflected in prominent critical accounts of contemporary art in the mid-1990s, which should be no surprise, since the production of art and the writing which supports it are hardly separable. Even so, there is a sharp contrast between much academic writing on art and art criticism. Academic writing has tended to be caught up in the continued dominance of deconstruction, old Freudian and Lacanian models (widely discredited in other fields), and identity-based accounts. In one sense, this writing, which consists of apparently wilful readings, abounding in poetic associations and arbitrary leaps, is a reflection of the freedom ideally found in art itself. The writer's performance is as creative as the artist's. Yet much academic art writing, too, demonstrates a hidden uniformity, produced by institutional pressures, beneath its apparently various surfaces. The particular advantage of the dominant deconstructive and psychoanalytical accounts is that they can be arbitrarily applied to the most unlikely of works with predictably 'critical' results: traumatic voids have even recently been discovered in the glib, slick surfaces of pieces by Sam Taylor-Wood. Once the method is learned, any material can be fed into the machine. Thus the publication quotas that are institutionally demanded of

boxes cannot be visually distinguished from actual Brillo Pad boxes, he argues, it follows that art cannot be defined in terms of its visual distinctiveness, and must instead be characterized philosophically. McEvilley is Distinguished Lecturer in Art History at Rice University, and has a PhD in classical philology. He is a contributing editor to Artforum, and has done much to promote the understanding of non-Western contemporary art. He came to wide attention with a systematic and stringent critique of the assumptions underlying the New York Museum of Modern Art's 1984 exhibition, 'Primitivism' in Twentieth Century Art, which led to a lengthy and fractious debate with the curators. Dave Hickey, Professor of Art Criticism and Theory at the University of Nevada, Las Vegas, a highly popular writer with an engaging prose style, is a recipient of the MacArthur Foundation 'genius award'. Each of these critics brings a set of particular and extraneous interests to art criticism, as many of the best writers on art have done: for Danto is it philosophy; for McEvilley anthropology and the classics; for Hickey popular music and literature.

Danto's After the End of Art claims that the character of art has changed radically since the 1970s and the last gasp of the avantgarde, and is now properly post-historical. Modernist and avantgarde views were tied to an idea of historical progress—towards formal abstraction, perhaps, or the merging of art and life. For

Danto, in contrast, 'life really begins when the story comes to an end', and those who now expect art to progress have missed the point, which is that the final synthesis has been reached. While Danto does not mention him, this stance is close to that of Francis Fukuyama's political views in his widely publicized book *The End of History and the Last Man*, and is based on the same Hegelian contention that, while of course events continue to occur, History has come to a close; that we are settled for ever with a version of the system which now sustains us. Similarly, for Danto, once art had passed through the black night of the 1970s (which he compares, with its dreadful politically engaged work, to the Dark Ages), it emerged onto the sunny Elysian Fields of universal permissiveness, never to leave. And in those fields, any mixing of styles or patching together of narratives is in principle as good as any other.

We have seen that, from one point of view, this is a good description of contemporary art, and is definitely plausible. It has had considerable resonance in the art world, and figures who are much at odds with Danto in other respects echo it. For instance in his book *Design and Crime* Hal Foster, one of the most influential and powerful academic writers about contemporary art, describes art's current 'symbolic weightlessness' and its disengagement from history:

One might go further: contemporary art no longer seems 'contemporary', in the sense that it no longer has a privileged purchase on the present, or even 'symptomatic', at least no more so than many other cultural phenomena (p. 124).

Danto wants to say that contemporary art is contemporary but that means more than merely art made now: 'the contemporary is, from one perspective, a period of information disorder, a condition of perfect aesthetic entropy. But it is equally a period of quite perfect freedom (p. 12).' That freedom was produced by the view of art that asked philosophical questions about its very conditions of existence, and was no longer tied to questions of how it looked. Liberated from the burden of that history, artists could make work 'in whatever way they wished, for any purposes they wished, or for no purposes at all' (p. 15). This is a fully utopian achievement, which Danto has little hesitation in comparing to Marx and Engels' vision of communism, in which people could freely fulfil themselves in the activities of their choosing.

In *Art and Otherness*, McEvilley's account of the contemporary art world, global others coming into equal and full voice have undermined modernist certitudes and allowed postmodern diversity to flower. Bad, old universal teleological modernism (as he characterizes it, with unnuanced readings of Kant and Greenberg) has been defeated by plural, forward-looking

postmodernism, through which we can glimpse possible utopian futures. The account of modernism given here (one that has more plausibility in the US, no doubt, where the figure of Greenberg still looms) is smooth and unitary, innocent of the many variations, contradictions, and disputations that it used to contain. In any case, given its passing, judgements of quality—once considered absolute—may be relativized, and in doing so we can draw on the tools of anthropology. According to McEvilley:

At moments of intense social ferment, art can serve to retard, disguise, or misrepresent a society's potential for change. Today, against all odds, art is performing the opposite role. Tracking the future, it senses avenues along which a new self may emerge into the light of a redefined history (p. 12).

In such uncertain times, artists produce works that are necessarily dark, oracular, and ambiguous, a faithful reflection of the epoch. Part of this uncertainty is due to the emergence of multiple non-Western views, and a corresponding relativization of Western values that McEvilley sees emerging particularly from the 1980s. For McEvilley this does not mean the end of history but the end of one singular and particular view of it. The ideological totality of modernism has yielded to a glorious plurality of positions; but this is not to say that no new synthesis will emerge, only that it has not yet been glimpsed. For the time being, that is just fine:

Why not let the world breathe for a while without a meta-narrative constricting it into a narrow space that is claimed as ultimate? Why not let it feel its way into the future without those totalizing, globalizing, universalizing, redemptionist myths which have so much in common with religious prophecies? (p. 145)

Like Danto's, this is a cheering view of the diversity of the contemporary art scene, and it gains plausibility because, while modernism was never as simple or unitary as McEvilley has it, there has been a decided and positive increase in the diversity of voices heard in the art world. In his writings about specific aesthetic milieux in Africa and Asia, McEvilley has furthered that change and proved more sensitive to the complexities and contradictions it implies than in the broad-brush claims he made in *Art and Otherness*.

Dave Hickey, too, wants viewers to relax, enjoy art, and especially to forget about the evils of the market. His book *Air Guitar* contains a plea to allow the arts to thrive free of academic brow-creasing at what Hickey describes as that specifically US invention—a 'big, beautiful art market' that simply and democratically reflects popular taste. Writing of the attitude of Las Vegas academics to their home town, he claims 'They think it's all about money, which, I always agree, is the worst way of discriminating among individuals, except for all the others' (p. 21).

For the alternative to the market, bred in state funding of the arts and propagated in academia, is a civil-service-run, politically correct, theoretically defended culture, comprising 'A "critique of representation", which, at its heart, is a critique of representative government—bald advocacy for a new civil service of cultural police' (p. 71).

Hickey's well-honed rhetoric is used to bolster the notion that 'democracy' is embodied in market mechanisms, so that the laws of supply and demand set the hierarchy of prices which really does reflect what people want from art. This view is loosely associated with the standard line of liberal thinking that says that you cannot have democracy without the market. It is another matter, though, to say that the market can act as a substitute for democracy. If that is a very doubtful claim even when applied to free markets, when applied to the art market—which, as we have seen, is highly archaic, controlled, and restricted—its foolishness is crystal clear.

For this view to appear remotely plausible, Hickey has to believe that cultural distinction does not matter, that to look at art requires no special skill or education, and that entry into the art world is a purely voluntary matter (if you want in, you are in). It is a touchingly idealist view for an art-world insider to hold, apparently innocent of the workings of social distinction, money,

and power. Hickey would have us believe that

everyone in this culture understands the freedom and permission of art's mandate. To put it simply: Art ain't rocket science, and beyond a proclivity to respond and permission to do so, there are no prerequisites for looking at it (p. 107).

There are certainly elements of truth in this: the arts as a profession is not defended against outsiders in the way medicine, law, or engineering are; appreciating art is definitely not rocket science, and people can understand a lot about it just from being exposed to the general run of commercial culture. However, the single biggest determinant of gallery-going is education (as we have seen), and this is partly because art at all levels (from academic to commercial) defines itself against mass culture. In doing so, it regularly uses complex references to art history that require specialist knowledge of its viewers. Hickey himself, far from being an ordinary Joe, spent years doing a PhD, thus leaping over the most forbidding barrier to access.

Hickey sees himself as a fan of art, just as he is a fan of rock and roll, and there should be no more need for a fan of art to trouble themselves about it being a commodity than they would worry over the buying and selling of CDs. To counter this view, we should turn to another well-known critic who has also written

much about rock—Diedrich Diedrichsen. In a mordant examination of the state of contemporary art criticism, he points to the obvious difference between fan literature and art criticism. Fan literature is written for those who are likely to buy a product, and helps them to decide whether or not to do so. As a result it is highly focused and instrumental. Nearly all the audience for art criticism, however, have no prospect of owning the works they are reading about. The writing, too—in its specialist academic and populist versions—serves quite other functions, in which judgements of quality are either not explicitly made at all, or are made only on the basis of a subjective parading of taste. Hickey's writing, of course, falls into the latter category.

Hickey has also recently curated an international exhibition in his campaign both to reinstate beauty and popularize art by removing what he sees as an elitist concern with political and social agendas. The show, which opened in 2001, Site Santa Fe's Fourth International Biennial was modestly entitled *Beau Monde: Toward a Redeemed Cosmopolitanism*. In the catalogue Hickey stated that, since what audiences remember of exhibitions is an ambience (and not ideas), he had resolved to touch everything there with high spirits and a light heart. The warehouse space at Site Santa Fe was transformed with gardens, a picture window, and fantastical architectural detailing, and works were disposed in

appealing vistas. Orthodoxy in biennials was the supposed target for the intended redemption. Hickey claimed they had been 'perversely devoted to marketing ideas of regional identity and local exceptionality in the normative language of post-minimalist artistic practice. He misunderstands what such shows are about. of course, for we have seen how they are founded on the idea of hybridity and cultural exchange, though Hickey is right about the unified language in which all this difference ends. This misunderstanding allows Hickey to recommend a cosmopolitanism in which cultural resources are mixed and which actually plays to the main presumptions underlying the internationalism he complains about. The actual contrast is more straightforwardly political and becomes clear in Hickey's extraordinary claims for the show: while exhibitions that deal with cultural identity tend to be made up of art that poses problems, the art in Beau Monde aspires to solve them: 'the visible resolution of cultural dissonance has its moral and intellectual consequences, its social allegories, its uses, and function' (p. 79) (It is curious here how Hickey's normal facility with plain language deserts him, perhaps under the pressure of the absurdity of the claim.) The mutation of the biennial in Beau Monde is an instructive one. Retaining the celebration of hybridity, it switches the standard response of the work from positive to negative, but

to similar propaganda effect; the conventional biennale recommends multiculturalism and complains that old, conservative barriers to trade and cultural exchange hold back its progress; *Beau Monde* gloried in its current successes and the beauty they produced.

The artist Renée Green has enumerated some current artworld clichés exemplified by Hickey's thinking:

- 1 Art is borderless
- 2 Thinking causes over-seriousness and the deflation of fun and beauty, which are equated with aesthetic pleasure.
- 3 To think means to think too much, and is in conflict with experiencing (which is thought of in binary terms and is thus associated with feeling, i.e., feeling/experiencing vs. thinking) (p. 248).

Hickey strangely presumes that people—and educated art audiences in particular—cannot take pleasure in a demanding work, or a political work, or even a play of ideas.

All three critics, Danto, McEvilley, and Hickey, arrive via very different routes at similar destinations: that the contemporary art world is (in the infamous words of Robert Venturi and his collaborators in a book, *Learning from Las Vegas*, that lies at one of the main roots of postmodernism) 'almost all right'. Viewers of art should be content to bask in its glorious and unencompassable diversity.

The rules of art now

We have seen that there are many reasons why that very diversity has become a prescribed uniformity. Bourdieu points to another: both the production and consumption of works that emerged from a long tradition of rupture with tradition carry with them a cargo of historical references, becoming simultaneously thoroughly historical and dehistoricized. They refer to a multitude of forms but truly remember none of them, nor the conditions of their creation. History is reduced to a pure history of forms, laid out like a table from which any combination of options can be selected.

Another way of saying that there is eclecticism—an equalizing and mixing of styles and histories—and the alluring 'real' of everyday life to back it up, is by claiming that the reality appealed to here is the real of money. It was put this way by Lyotard in his foundational treatise on postmodernism, and has recently been reiterated with force by Hardt and Negri, in their influential reconsideration of global governance and economics, *Empire*, where, as we have seen, they drew out the close parallels between postmodernism and the market.

The remarkable feature of this scenario is the convergence between academic interpretations of art and those more populist writings that recommend the untroubled enjoyment of beauty. Academics, who are committed to applying Occam's Razor in reverse to any conceivable cultural problem, and critics who strive for a reasonable, measured, and entertaining clarity both favour fragmentation, the divided subject or psyche, the limits and bad faith of socially produced knowledge, and the sublime vertigo of the unknowable. And they do so at a time when art is increasingly dominated by thoroughly comprehensible tactics and techniques.

In any case, the plausibility of these views has lately taken a battering. Particularly since the events of September 11, the rise of overt US imperialism—with its flagrant and insouciant flouting of international law—strikes against the ideal multiculturalism and globalization exemplified in McEvilley's account. The return of a cogent opposition to capitalism, and with it of vanguard art, should have been impossible if Fukuyama's and Danto's accounts were accurate. Hickey's boosting of beauty and the market looked good only as long as the economy boomed, and art-consumers continued to indulge themselves with pretty objects. We shall see in the final chapter how these factors and others exacerbated existing tensions in the art-world system.

Contemporary art, sure, but contemporary with what?

(Paul Virilio, Art and Fear)

In ideology, things appear upside-down, Marx and Engels claimed, and contemporary art celebrates as the exercise of freedom all that is forced on us. If it is able to do so plausibly this is because the experience of the elite who view art is of freedom, the adopting and discarding of roles, and the multiple identities constructed through consumer choice. Recent events—the attack of another global recession, the rise of radical political movements, and the many consequences of an overtly imperial project pursued by the US—have begun to fracture the longstanding agreement about art's role and character. As a result, some very diverse views about art are beginning to be aired, even from within the intelligentsia.

Two recent French accounts of contemporary art may serve as examples. For Nicolas Bourriaud, in his influential book *Relational Aesthetics*, 1990s art has been most characterized by work that makes social interaction an aesthetic arena, in which artists offer services or contracts to visitors or simply facilitate talk between them. One of his examples illustrates the idea well: Jens Haaning broadcast jokes in Turkish through a speaker in a Copenhagen square, forging a temporary bond between those who understood and laughed. For Paul Virilio, in lectures published as

Art and Fear (and very badly received when they were published in France in 2000), the logic of art continually engages in breaking taboos, in ramping up spectacle, and in stretching the limits of what it is to be human—even to the extent of engaging in creative genetic manipulation: such logic ultimately points towards murder for aesthetic purposes. Sergei Bugaev Afrika (see chapter 2) made a work based on documentary footage of the slaughter of a Russian patrol by Chechen rebels—a snuff movie for aesthetes. Work such as Afrika's sanctions Virilio's position on the pitilessness and noise of contemporary art. While conventionally and ideally, truth, beauty, and ethics have been aligned, Virilio poses the following question, as if one could only have either one or the other: Ethics or aesthetics?' (p. 61).

The difference between the two views is partly due to the writers' backgrounds: Bourriaud is a curator and currently a codirector of the state-run contemporary art space at the Palais de Tokyo in Paris. His views were formed by working with and talking to artists. His book is not merely a discussion but a promotion of the art that he recommends by figures such as Vanessa Beecroft, Liam Gillick, Philippe Parreno, Rirkrit Tiravanija, and others. Virilio is a veteran philosopher, urbanist, and political activist, whose involvement in the art world goes back to working on stained glass with Braque and Matisse. His thinking,

particularly about vision, speed, and war, has tended towards the apocalyptic, and it is unsurprising that he writes about current art as an outsider.

For Bourriaud, art that encourages social interaction among its viewers reacts directly against a general trend to increasing social fragmentation, from ever greater specialization at work to the tendency for people to lock themselves away in their homes in the company of media rather than other people. This condition is eased through art: 'Through little services rendered, artists fill in the cracks in the social bond.' (p. 36) Such work offers not theoretical prescriptions but small, momentary, and subjective 'hands-on utopias' in which people can learn to live in a better way. Yet this 'arena of exchange' must be judged aesthetically, through an analysis of its form. Social relations are treated as another artistic medium to add to photography, video, and installation. These works may well include things that look like conventional art objects and which may be bought and sold, though they too should be judged ultimately as part of the overall scene of sociality. Even the participants have an aesthetic relation to the work, for they both act and have a consciousness of themselves acting (in the way that you do in an artificial social environment set up in a gallery). This art, claims Bourriaud, is human and democratic.

A good example of the type of art that Bourriaud recommends is Gavin Turk's *The Che Gavara Story*. This event followed a series of works made by Turk in which he had inserted his own face into well-known images of Che in black-on-red hoardings and in a waxwork mock-up of the famous photograph taken to prove that the revolutionary was dead. In 2001, in an ambitious departure from this previous line of work, Turk staged a series of meetings and discussion sessions about Che's life and legacy in a squatted room in Shoreditch. Political strategy meetings were followed by sessions in which activists would organize a demonstration that was to be the culmination of the series. The idea of this work, said Turk, was to use his status as a newsworthy artist to set up a space for discussion and action that would have a chance of breaking into the mass media.

The revived attraction of Che is that his life and image synthesizes youthful glamour and steadfast revolutionary committment, the one adding a tinge of half-forgotten danger to the other. This action seemed quite different from the works in which Turk had appropriated Che's image to make art objects, though the allure of the guerrilla-martyr was still in play. Part of the idea was to highlight the mismatch between Latin American revolutionary politics and the glittering banalities of 'young British art', thus fixing, according to Turk, on what shines out of

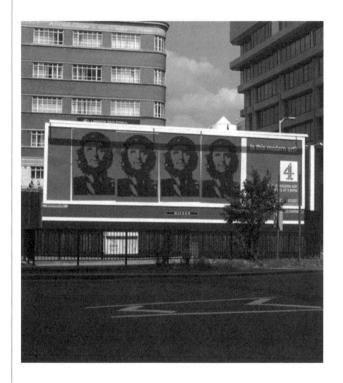

18 Gavin Turk, Che.

history into the present. The Left's old struggles have begun to shine anew because of the rise of anti-capitalist movements, which have worked out new ways to ally political and cultural action. They embody just that dangerous compact of cultural and political radicalism of which Che's image is a reminder.

Che had his guerrillas read *Don Quixote*, and Cervantes is also referred to regularly by Subcommandante Marcos of the Zapatistas. Turk's project was Quixotic in a different way. You cannot get a few diverse folk together over the course of a fortnight and conjure a political programme out of the air. The discussion I attended had many points of interest but felt aimless and unfocused, and others I spoke to who had attended the sessions felt similarly. Bizarrely, the final manifestation was dominated by nudists arguing for their right to go naked in public.

The Che Gavara Story demonstrated a number of key features of socially interactive works. Firstly, there is a trade-off between the number of participants and their diversity and likely discourse. Active participants tend to be few, elite, and self-selecting. Secondly, in these temporary utopian bubbles, no substantial politics can be arrived at, not least because even among those who do attend, real differences and conflicts of interest are momentarily denied or forgotten. A merely gestural

politics is the likely result. If, following Bourriaud, one's primary interest in such manifestations is aesthetic, this hardly matters.

In a sense, the use of audience interaction reintroduces organic and irrefutable presence to an art that threatens to become an evacuated play of ready-made signs and objects. The presence is no longer that of the artist-genius, but of the audience temporarily warmed by the glow of a democratic ideal that treats their thoughts and actions as valuable, or at least recognizes their potential for creative engagement.

If all this seems a self-consciously futile and token activity, then the rise of this art may be less positive than Bourriaud thinks. Coupled with thinking about the hollowing out of democratic politics (remember the Swedish 'average citizen'), what Bourriaud describes is merely another art-world assimilation of the dead or the junked, the re-presentation as aesthetics of what was once social interaction, political discourse, and even ordinary human relations. If democracy is found only in art works, it is in a good deal of trouble.

This type of art is, however, congenial both to governments (particularly those of a social-democratic inflection, hence its prevalence in Europe during the 1990s) and business.

Governments, as we have seen, look to art as a social salve, and hope that socially interactive art will act as bandaging for the

grave wounds continually prised open by capital. Corporations may also employ it specifically to leaven workplace environments with creative play, and free up company structures and methods with innovative thinking. Art is refashioned as management consultancy.

By contrast, Virilio's remarks about contemporary art were far from congenial to states, business, or the art world. They do have many faults, being expressed in extreme, hectoring language, containing bad errors, and setting out to provoke by associating most contemporary production directly with mass murder. Even so, they clearly express a concern that such art places itself against human discourse, stillness, and contemplation, and at the service of instrumental powers. To bring Bourriaud's and Virilio's views together, we may say that one of art's tactics for doing this is precisely by repackaging social interaction as aesthetic performance.

The logic of capital churns up all material, bodies, cultures, and associations in the mechanical search for profit making. This has its analogue in art's weightless sign-swapping. For Virilio, art's creativity, allied to capital, is directed against humanity itself, most obviously in its embrace of the genetic manipulation. There have been numerous visions of genetically modified humans in recent digital photography—for example, by Margi Geerlinks and Inez

van Lamsweerde—which help, with their smooth spectacle, to glamorize the possibilities for the creative alteration of genes. Other artists go further in claiming to have actually manipulated the genes of living organisms for artistic effect. Whether or not Eduardo Kac really did genetically engineer a green fluorescent rabbit as an artwork, the point is clear: the artist has the right to use genetic manipulation for declaredly aesthetic ends.

In the face of this incessant transformation, the greatest ideological redoubt is the subjectivity of the viewer. Long ago, Leo Steinberg felt that an interactive piece by Robert Rauschenberg had reduced him to the status of a switch. This was near the beginning of cybernetic work that indeed had such designs on us. Yet, despite the most transparent manipulations of the viewer, their inviolable character and the linked mystery of art persist. Bourdieu broaches the question (quoted on page 9) why art must escape all explanation. To ask for explanations, he says, 'constitutes a mortal threat to the pretension, so common (at least among art lovers) and yet so "distinguished" of thinking of oneself as an ineffable individual, capable of ineffable experiences' (p. xv).

So, ultimately, art's purpose is to assure its educated viewers that, despite the corruption of democracy, the manipulations of the media, the pollution of the mental environment by endless

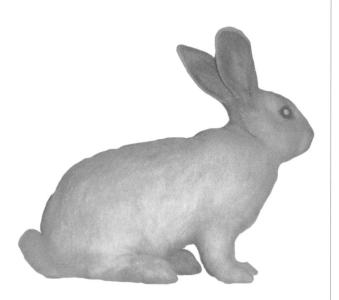

19 Eduardo Kac, GFP Bunny.

and strident commercial propaganda, they are still themselves, undamaged and free. They can even engage in meaningful social discourse with like-minded strangers, when artists sanction it.

The universal viewer is set against a universalism of another kind. Serge Guilbaut showed how the regionalism and nationalism—the particular local concerns—of the US art world had to fall away as it moved to take on global dominance. In a further stage, that dominance is sublimated, so that it no longer requires that art be American, only that it be made according to the US-enforced model of global neoliberalism.

It may be concluded that the most celebrated contemporary art is that which serves to further the interests of the neoliberal economy, in breaking down barriers to trade, local solidarities, and cultural attachments in a continual process of hybridization. This should hardly be a cause for surprise but there is a large mismatch between the contemporary art world's own view of itself and its actual function.

Art overruns the borders of local particularity, aiding the transformation and mixing of the world's cultures and economies. The progressive and regressive aspects of this process are inextricably related. Local resistances are defeated and, in many places, conditions worsen as a result. Equally, art prepares the way for greater integration, and for the emergence of wider

solidarities, so compellingly laid out in Hardt and Negri's book *Empire*. Even so, any progressive aspect to the art world's support of neoliberalism is the inverse of its own view of its actions, which are fixed on the particular, the personal, and the non-instrumental, and certainly not on the sacrifice of particularities on the altar of global homogenization. It is just this mismatch that constitutes art's main contribution to what is generally, after all, far more effectively carried on by mass culture: an appeal to sections of the elite that stand above and aside from their local cultures, and a particularly effective ideological cloak for the actions of that audience in their engagement with global capital.

There are, however, distinct tensions and contradictions in this situation. We have seen that art's uselessness—its main use—is being sullied by the particular needs of government and business. In a linked development, art's elitism is challenged by the attempt to widen its appeal: business values art for its exclusivity, while states are generally interested in the opposite, and wish to widen its ambit. Finally art's means of production, increasingly technological, have come into conflict with its archaic relations of production.

Opportunities for the exploitation of these tensions fall into four main categories. Firstly, there is iconoclasm. The destruction of art, or even the attempt to do, is the most basic protest against

the notion implicit in contemporary art that all signs are equally open to play. The relatives of Myra Hindley's victims thought that her image should not be open to such toying with, and were supported by two people who tried to damage Marcus Harvey's Myra during its display at the Sensation exhibition; likewise Chris Ofili's Holy Virgin Mary, which juxtaposed the main figure with cut-outs from pornographic magazines, was attacked when Sensation was shown in New York. Such acts also challenge the commonly-held view that all art is a good, a product of sovereign self-expression. When public works of art are attacked their setting, purpose, and the politics of their commissioning are all highlighted. The well-planned arson attack in Birmingham on Raymond Mason's Forward (1991), much disliked by many locals, was an exercise of vulgar power over a piece of municipal propaganda.

The second and the third categories are political activism in art, and the linked exploitation of technological means to sidestep the art-world system. There has been some explicit critique of neoliberalism within the global biennales. The two most recent Documentas have both made political engagement a theme: *Documenta X* in 1996, curated by Catherine David, courageously took on the apolitical character of the art world at the height of the 1990s boom, and as a result was roundly

condemned in many quarters for being backward-looking and nostalgic. *Documenta 11*, curated by Okwui Owenzor, was another clear sign that the art of the periphery had moved centre-stage, and contained an impressive array of critical work, buttressed by discussions taking place at many venues around the world and the publication of dialogues on democracy, truth and reconciliation, creolization and the Latin American city. Yet as long as such work remains within conventional art-world structures, such critiques contain self-evident contradictions that weaken their likely power.

In a small, jokey book—a dialogue between Matthew Arnatt and Matthew Collings about *Documenta 11*, though equally about themselves and the rhetoric of criticism—the two writers express unease at the parade of otherness. Collings, typically and for the sake of making the reader feel better about their own forgetfulness and lack of expertise, has only vague and jumbled memories of what he has seen, though he remembers objecting to

seeing what I later remembered as endless piles of charred twigs and with gospel music playing. Actually when I analysed this fantasy memory it was really one particular pile of old bits of cars, from South Africa, maybe, made into a visually horrible sculpture thing, which really did have gospel music playing. And everyone on the platform ... at the press

conference, was pulling faces and feeling the pain of suffering, or suffering pain, or at least mincing and wincing a lot) (pp. 10–11).

The serious point here is that such reactions are agreed to in advance. For those, like Collings, who are hostile to 'politically correct' presumptions, such works are powerless.

Arnatt, in combative baroque prose that echoes Wyndham Lewis, puts his finger on what the movement of these visions—from the point of their making to the German art extravaganza—might amount to:

things remain horribly Wodehousian—especially in their formidable domesticity, i.e. everyone 'Knows' on the basis of an inverted gnosis—something like a principled snobbery—that employs into 'service' the creatures of Africa (richly coloured and dancing given half-a-chance), and the tortured 'sensibilities' of the geographically distanced victims of political and economic 'atrocity'—and uniforms them. In that way—the centre's apology for its own centrality—draws into its own hideous and kinky household, with the relish of a Mrs Beaton, the exotic fruit of otherness, and pounds it into a jelly; disgusting(p. 12).

He also argues that there is a contradiction between the professional individualism of such an event (curators, just like artists, attempt to occupy a unique space) and its radical preoccupations (which would seem to tend towards

collectivism). A gnostic view of the 'dark continent' versus the civilized West that leads to automatic breast-beating is indeed a racist fiction; but that caricature should not blind viewers to the overall operation of global capitalism, nor to its most disastrous effects in sub-Saharan Africa where, after all, the prolonged strife is over goods, diamonds and oil, meant for largely wealthy markets

The bad faith involved in the display of these problems in art, however, is not that these subjects are reflex reactions of the Left, nor that blame fails to attach to the people before which it is paraded; the bad faith lies in the very slight likelihood that the art world alone can do anything to help. If the work is shown without any prospect that it will have an effect, its display becomes mere performance and its viewing a form of entertainment. It will be said that the art world is not separated by impermeable barriers from the rest of society, so these displays may have a wider effect. Yet art's marginality, when compared to the rest of the culture, means that those effects are most likely minor. Walter Benjamin's old point still holds: a radical art needs to do more than make politics its subject-matter; it must change the way it is made, distributed, and seen.

One response is to step outside the conventional arena of gallery and museum display. From the mid-1990s, with rise of the

web browser, the dematerialization of the art work—especially its weightless distribution over digital networks—has threatened the protected system of the arts. What is the market to make of a work that is reproducible with perfect accuracy, that can simultaneously exist on thousands of servers and millions of computers, and that can be cannibalized or modified by users? How can one buy, sell, or own such a portion of data? This is a situation, central to Marxist theory, in which modernization of the means of production comes into conflict with the relations of production. In digital art, the use of the most up-to-date technological means to make and distribute work comes into conflict with the craft-based practice, patronage, and elitism of the art world

Artists made interventions in online space, alongside corporations that made concerted efforts to transform the Internet from a forum to a mall. That commercial colonization has been a rich subject for Internet artists, who have produced many sharp and sophisticated pieces designed to draw the shopper up short. One of the most notorious was staged by the art corporation etoy. Their *Digital Hijack* diverted surfers who had typed in keywords such as 'Madonna', 'Porsche,' and 'Penthouse' into a search engine, and clicked on etoy's top-rated site, greeting them with the response: 'Don't fucking move. This is a digital

20 Etoy, Toywars picture.

hijack', followed by the loading of an audio file about the plight of imprisoned hacker Kevin Mitnick, and the hijacking of the Internet by Netscape. Others—including Rachel Baker, with her examination of customer surveys, data mining, and loyalty cards—have come into dispute with corporations using the copyright laws to suppress freedom of speech. Baker made a site promising Web users who registered for a Tesco loyalty card points as they surf, provided they filled in a registration form that asked questions such as 'Do you often give your personal data to marketers?' and 'How much is your personal data worth to marketing agents?' She rapidly received a letter from Tesco threatening an injunction and damage claims.

This form of art is indicative of a wider, extraordinary development: out of a renewed and virulent species of capitalism—at the point of its apparent triumph—there condensed from fragmented single-issue politics a coherent movement of opposition. Michael Hardt and Antonio Negri argue that this is no accident, for cooperative values emerge from the very change of the primary economies towards data processing, in which cooperation between users and producers can be a more important organizing force than investment capital. The result is 'the potential for a kind of spontaneous and elementary communism' (p. 294). The Open Source or free software

movement—based on just this global, voluntary cooperation protected by a hacked form of copyright law—is a challenge to the dominance of Microsoft and provides a striking example of such collective work in action.

The fourth tactic for exploiting tensions within contemporary art is to challenge the illusion of art's uselessness by producing work of explicit use. The synthesis of productive and reproductive technologies in the digital realm raised two corpses long thought to have been definitively buried: the avant-garde and the political use of art. For Benjamin Buchloh, a key example of art that had a use-value was Soviet constructivism, made following the Revolution for particular, well-defined purposes (p. 198). Especially online, where the boundaries between production and reproduction are faint, artists have been rediscovering use-value. Paul Garrin has battled the exclusive and centrally controlled naming of sites on the Web, which, he argues, works against its democratic potential. He has designed a working technical solution, Name. Space and insisted on its practical and political use, contrary to those who think a work of art must be functionless Other activist works allied to the new political movements—such as Floodnet, designed by Brett Stalbaum—have engaged in the direct disruption of consumerism. A campaign against the giant online corporation,

eToys—which had used legal action to close down the site of art collective etoy—was so effective that the campaign (along with the recession) forced the company into receivership. Perhaps the most radical and productive works of the last few years have not been those that dwelt on and within the power of consumerism but those that have explored its limits, and what lies beyond.

Art on the Net clearly raises—more than their vestigial treatment in the gallery—issues of dialogue and democracy. Here democracy is severed from the market, dialogue is rapid, borrowing is frequent, openness is part of the ethos, and there is a blurred line between makers and viewers. There are the beginnings of a sacrifice of the sovereign artist and solitary viewer in favour of communal participation and—that most necessary and elusive of cultural qualities—meaningful and effective feedback.

Such useful works are not confined to the online world, though they can flourish there because corporate sponsorship and museum curatorship do not define what is seen. Allan Sekula has produced a substantial body of work, interweaving photographs and texts, and tackling large subjects in ambitious, long-term projects—maritime trade, for instance, in his self-reflexive and sophisticated book, *Fish Story*. More recently, he made a smaller intervention of a few dozen pictures that has

appeared in galleries as a slide sequence (it was shown tellingly in the fascist Columbus Monument in Lisbon), and also follows the texts in a book called *Five Days that Shook the World*. This piece is called *Waiting for Tear Gas (White Globe to Black)*. The 'Five Days' are the anti-World Trade Organization demonstrations that took place in Seattle towards the end of 1999. The texts that frame these pictures—by Alexander Cockburn and Jeffrey St. Clair—describe the aims, the tactics, and the factions among the protestors, and the brutal (indeed, potentially lethal) response of the police. Sekula himself, unusually, does not support the pictures with much text, arguing that in the face of such strangeness a 'simple descriptive physiognomy was warranted'. Further:

I hoped to describe the attitudes of people waiting, unarmed, sometimes deliberately naked in the winter chill, for the gas and the rubber bullets and the concussion grenades. There were moments of civic solemnity, of urban anxiety, and of carnival (p. 122).

So in waiting, frozen moments are sealed in the photographic frame, but a wealth of time is contained in them, forward-looking most certainly in expectation and dread; backwards, too, for there is something archaic about both the demonstrations and these images, a feeling of history reasserting itself. What has reactivated

21 Allan Sekula, Waiting for Tear Gas.

time in such pictures? It is not the events of Seattle alone but the way they seem built into a wider system of change, as formerly fractious single-issue groups coalesce into a broad critique of the way things are. The positive project of the new movements is vague and contested but its broad outlines are evident: to protect the environment, to increase equality, and to make democracy mean more than the periodic election of leaders and parties in otherwise unchanging plutocracies.

Again, such a work has clear propaganda value, and does not seek to mystify itself or flatter viewers by assuring them of their own depthless profundity. It may be, of course, that the gallery display of this work rebounds to the honour of its hosts. Yet the work's clear and specific wider role works against that function, for it is unsuited to the usual cloudy idealisms that waft about the status of art and the gallery.

The question of art's use takes us back, naturally, to art's freedom. That the very concerns of art—creativity, enlightenment, criticality, self-criticism—are as instrumentally grounded as what they serve to conceal—business, state triage, and war—is the consideration that must be concealed. And it can be because the local liberation offered in the production of art, and its enjoyment, are genuine. Bourdieu cites a letter by Flaubert on art's freedom:

That is why I love Art. There, at least, everything is freedom, in this world of fictions. There one is satisfied, does everything, is both a king and his subjects, active and passive, victim and priest. No limits; humanity is for you a puppet with bells you make ring at the end of his sentence like a buffoon with a kick (p. 26).

Flaubert more than implies that the free mastery of the artist (and reader or viewer) is a cruel power. In Bourdieu's analysis. Flaubert's freedom, and that of the avant-garde in general, was purchased at the price of actual disconnection from the world of the economy. Other bohemian writers were the main and grossly inadequate market for such work, and books were written in deliberate defiance of bourgeois understanding. The autonomy of art was carved out of a reaction against both elevated bourgeois writing and engaged, realist literature; acclaim was only—if ever—achieved after the long passage of time, as new avant-garde forms displaced and familiarized the old. It is easy to see that the conditions for that freedom no longer exist in the art world: artists are snug in the market's lap; works are made to court the public; sufficient autonomy is maintained to identify art as art, but otherwise most styles and subject-matter are indulged in; success generally comes swiftly, or not at all.

In these circumstances, the plausibility and power of art's

freedom are on the wane. Among the opening remarks of *Aesthetic Theory*, Adorno has this to say about artistic freedom: 'absolute freedom in art, always limited to a particular, comes into contradiction with the perennial unfreedom of the whole.' Until that wider unfreedom is effaced, the particular freedoms of art run through the fingers like sand. While they may open a utopian window on a less instrumental world, they also serve as effective pretexts for oppression. In these circumstances, it is works of evident use that press on the contradictions inherent in the system of art, that seek to liberate themselves from capital's servitude. To break with the supplemental autonomy of free art is to remove one of the masks of free trade. Or to put it the other way around, if free trade is to be abandoned as a model for global development, so must its ally, free art.

Chapter 1: A zone of freedom?

References

Rasheed Araeen, The Other Story: Afro-Asian Artists in Post-war Britain, Hayward Gallery, London 1989.

The Art Sales Index: www.art-sales-index.com

Pierre Bourdieu, *The Rules of Art: Genesis and Structure of the Literary Field*, Polity Press, Cambridge 1996.

Benjamin Buchloh, 'Critical Reflections', *Artforum*, vol. 35, no. 5, January 1997, pp. 68–9, 102.

Centre Georges Pompidou, *Magiciens de la terre*, Paris, Editions de Centre Pompidou, Paris 1989.

Douglas Davis, 'Multicultural Wars', Art in America, vol. 83, no. 2, February 1995, pp. 35–9, 41, 43, 45.

Jacques Derrida, Of Grammatology, trans. Gayatri Chakravorty Spivak, Johns Hopkins University Press, Baltimore 1976, pt. II.

Thelma Golden, *Black Male: Representations of Masculinity in Contemporary American Art*, Whitney Museum of American Art, New York 1994.

Karl Marx and Frederick Engels, The Communist Manifesto: A Modern Edition, Verso, London 1998.

Julie H. Reiss, From Margin to Center: The Spaces of Installation Art, The MIT Press, Cambridge, Mass. 1999.

Justin Rosenberg, The Follies of Globalisation Theory, Verso, London 2000.

Martha Rosler, 'Money, Power, Contemporary Art', *Art Bulletin*, vol. 79, no. 1, 1997, pp. 20–4.

Donald Sassoon, 'On Cultural Markets', *New Left Review*, new series, no. 17, September/October 2002, pp. 113–26.

Joseph Stiglitz, Globalization and Its Discontents, Allen Lane, London 2002.

Further reading

Richard Bolton, ed., Culture Wars: Documents from the Recent Controversies in the Arts. New Press. New York 1992

Eric Hobsbawn, Behind the Times: The Decline and Fall of the Twentieth Century Avant-Gardes. Thames and Hudson, London 1998.

Serge Guilbaut, How New York Stole the Idea of Modern Art: Abstract Expressionism, Freedom, and the Cold War, trans. Arthur Goldhammer, University of Chicago Press, Chicago 1983.

Patricia Morrisroe, Mapplethorpe: A Biography, Macmillan, London 1995.
Brian Wallis, Marianne Weems, and Philip Yenawine, Art Matters: How the
Culture Wars Changed America, New York University Press, New York
1999

Peter Watson, From Manet to Manhattan: The Rise of the Modern Art Market, Hutchinson, London 1992.

The Frances Young Tang Teaching Museum and Art Gallery at Skidmore College, Kara Walker: Narratives of a Negress, The MIT Press, Cambridge, Mass 2003

Chapter 2: New world order

References

Stanley K. Abe, 'No Questions, No Answers: China and A Book from the Sky, in Rey Chow, ed., Modern Chinese Literary and Cultural Studies in the Age of Theory: Reimagining a Field, Duke University Press, Durham, NC 2000.

Carol Becker, 'The Romance of Nomadism: A Series of Reflections', *Art Journal*, vol. 58, no. 2, Summer 1999, pp. 22–9.

Homi K. Bhabha, *The Location of Culture*, Routledge, London 1994. Alexander Brener, 'Ticket that Exploded':

- http://www.ljudmila.org/interpol/intro2.htm
- Jen Budney, 'Who's It For? The 2nd Johannesburg Biennale', *Third Text*, no. 42, Spring 1998, pp. 88–94.
- Mikhail Bulgakov, *The Heart of a Dog*, trans. Mirra Ginsburg, Picador, London 1990
- Noam Chomsky and Edward S. Herman, Manufacturing Consent: The Political Economy of the Mass Media, Pantheon Books, New York 2002.
- Eugenio Valdés Figueroa, 'Trajectories of a Rumour: Cuban Art in the Postwar Period', in Holly Block, ed., *Art Cuba: The New Generation*, trans. Cola Franzen/Marguerite Feitlowitz, Harry N. Abrams, Inc., New York 2001.
- Jean Fisher, quoted in Kobena Mercer, Ethnicity and Internationality: New British Art and Diaspora-Based Blackness, *Third Text*, no. 49, Winter 1999–2000, pp. 51–62.
- Coco Fusco, *The Bodies that Were not Ours and Other Writings*, inIVA/Routledge, London 2001.
- Eduardo Galeano, *Memory of Fire*, trans. Cedric Belfrage, Quartet Books, London 1995.
- Stuart Hall, 'New Ethnicities', in David Morley and Kuan-Hsing Chen, eds., Stuart Hall: Critical Dialogues in Cultural Studies, Routledge, London 1996.
- Hou Hanrou, interviewed in Franklin Sirmans, 'Johannesburg Biennale: Meet the Curators of "Trade Routes: History and Geography", Flash Art, vol. 30, no. 190, October 1997, pp. 78–82.
- Fredric Jameson, 'Marxism and Postmodernism', in The Cultural Turn: Selected Writings on the Postmodern, 1983–1998, Verso, London 1998.
- 1st Liverpool Biennial of International Contemporary Art:Trace, Liverpool Biennial of International Contemporary Art/Tate Liverpool, Liverpool 1999.
- Thomas McEvilley, 'Report from Johannesburg: Towards a World-class

City?', Art in America, vol. 83, no. 9, September 1995, pp. 45-7, 49.

David McNeill, 'Planet Art: Resistances and Affirmation in the Wake of "9/11", Australian and New Zealand Journal of Art, vol. 3, no. 2, 2002, pp. 11–32.

Rosa Martínez cited in Carlos Basualdo, 'Launching Site', *Artforum*, vol. 37, no. 10, Summer 1999, pp. 39–40, 42.

Charles Merewether, 'Naming Violence in the Work of Doris Salcedo', *Third Text*, no. 24, Autumn 1993, pp. 31–44.

Boris Mikhailov, Case History, Scalo, Zurich 1999.

Gao Minglu, Extensionality and Intentionality in a Transnational Cultural System, *Art Journal*, vol. 57, no. 4, Winter 1998, pp. 36–9.

Gerardo Mosquera, 'New Cuban Art Y2K', in Holly Block, ed., Art Cuba: The New Generation, trans. Cola Franzen/Marguerite Feitlowitz, Harry N. Abrams, Inc., New York 2001.

Moderna Musset, Organising Freedom: Nordic Art of the '90s, Stockholm 2000

Tom Patchett, ed., *Most Art Sucks: Five Years of Coagula*, Smart Art Press, Santa Monica 1998.

Katya Sander and Simon Sheikh, eds., We Are All Normal (and We Want Our Freedom): A Collection of Contemporary Nordic Artists' Writings, Black Dog Publishing, London 2001.

Måns Wrange, To Change the World: On Statistical Averages, the Art of Social Engineering and Political Lobbying, in Sander and Sheikh, *We Are All Normal*. See also www.averagecitizen.org

Slavoj Žižek, 'Multiculturalism, or, the Cultural Logic of Multinational Capitalism', *New Left Review*, no. 225, September–October 1997, pp. 28–51.

Further reading

Manthia Diawara, 'Moving Company: The Second Johannesburg Biennale',

- Artforum, vol. 36, no. 7, March 1998, pp. 86-9.
- Britta Erickson, Words without Meaning, Meaning without Words: The Art of Xu Bing, Arthur M. Sackler Gallery (Smithsonian Institution), Washington, DC 2001.
- Peter Gowan, 'Neoliberal Theory and Practice for Eastern Europe', New Left Review, no. 213, September–October 1995, pp. 3–60.
- Hanart Gallery, Wenda Gu: The Mythos of Lost Dynasties, Taipei 1997.
- Hou Hanrou and Hans Ulrich Obrist, eds., Cities on the Move, Verlag Gerd Hatje, Ostfildern-Ruit 1997.
- Moderna Musset, After the Wall: Art and Culture in Post-Communist Europe, Stockholm 1999.
- Saskia Sassen, *The Global City: New York, London, Tokyo*, Princeton University Press, Princeton 1991.
- Donald Sassoon, One Hundred Years of Socialism: The West European Left in the Twentieth Century, I.B. Tauris, London 1996.
- Bernd Scherer, 'Johannesburg Biennale: Interview with Lorna Ferguson', Third Text, no. 31, Summer 1995, pp. 83–8.
- John C. Welchman, Art After Appropriation: Essays on Art in the 1990s, G+B Arts International, London 2001.
- Xiaoping Lin, 'Those Parodic Images: A Glimpse of Contemporary Chinese Art'. *Leonardo*, vol. 30, no. 2, 1997, pp. 113–22.

Chapter 3: Consuming culture

References

- Theodor W. Adorno, *Negative Dialectics*, trans. E.B. Ashton, Routledge, London 1973
- Theodor W. Adorno, 'Free Time', in *The Culture Industry: Selected Essays on Mass Culture*, ed. J.M. Bernstein, Routledge, London 1991.
- Benjamin H.D. Buchloh, 'Moments of History in the Work of Dan Graham'

and 'Parody and Appropriation in Picabia, Pop, and Polke', in *Neo-Avantgarde and Culture Industry: Essays on European and American Art from 1955 to 1975*, October, Cambridge, Mass. 2000.

Claude Closky, www.sittes.net/links

Dallas Museum of Art and Metropolitan Museum of Art, New York, Thomas Struth. 1977–2002. Dallas 2002.

Diedrich Diedrichsen, 'The Boundaries of Art Criticism: Academicism, Visualism and Fun', in Jürgen Bock, ed., From Work to Text: Dialogues on Practise and Criticism in Contemporary Art, Fundação Centro Cultural de Belém. Lisbon 2002.

Marcel Duchamp, 'Apropos of "Ready-mades", talk delivered at the Museum of Modern Art, New York, 19 October 1961, in Michel Sanouillet and Elmer Peterson, eds., The Essential Writings of Marcel Duchamp, Thames and Hudson, London 1975.

Thomas Frank and Matt Weiland, eds., Commodify Your Dissent: Salvos from The Baffler, W.W. Norton, New York 1997.

John Frow, Time and Commodity Culture: Essays in Cultural Theory and Postmodernity, Clarendon Press, Oxford 1997.

Michael Hardt and Antonio Negri, *Empire*, Harvard University Press, Cambridge, Mass. 2000.

Fredric Jameson, *Postmodernism or, the Cultural Logic of Late Capitalism*, Verso, London 1991 chapter 1.

Naomi Klein, No Logo: Taking Aim at the Brand Bullies, Flamingo, London 2000.

Fernand Léger, 'The Machine Aesthetic: The Manufactured Object, the Artisan, and the Artist' (1924), in *Functions of Painting*, ed. Edward F. Fry, Thames and Hudson, London 1973.

Karl Marx, Capital: A Critique of Political Economy, Volume I, trans. Ben Fowkes, Penguin Books, Harmondsworth, Middlesex 1976.

- Karl Marx, Grundrisse: Foundations of the Critique of Political Economy (Rough Draft), trans. Martin Nicolaus, Penguin Books, Harmondsworth, Middlesex 1973.
- Vladimir Mayakovsky, 'Broadening the Verbal Basis', Lef, no. 10, 1927; reprinted in Anna Lawton, ed., Russian Futurism through Its Manifestoes, 1912–1928, Cornell University Press, Ithaca, NY 1988.
- Martha Rosler, 'Video: Shedding the Utopian Moment', in Doug Hall and Sally Jo Fifer, eds., *Illuminating Video: An Essential Guide to Video Art*, Aperture/Bay Area Video Coalition, New York 1990.
- Dan Schiller, Digital Capitalism: Networking the Global Market System, The MIT Press, Cambridge, Mass. 1999.
- Susan Sontag, 'Notes on "Camp", in *Against Interpretation* [1961], Vintage,
- Tate Liverpool, *Shopping: A Century of Art and Consumer Culture*, ed. Christoph Grunenberg/Max Hollein, Hatje Cantz Publishers, Ostfildern-Ruit 2002.
- Wolfgang Tillmans, If One Thing Matters, Everything Matters, Tate Publishing, London 2003.
- Walker Art Center, Let's Entertain: Life's Guilty Pleasures, Minneapolis 2000. Andy Warhol, The Philosophy of Andy Warhol (From A to B & Back Again), Harcourt. Brace, Jovanovich, New York 1975.
- Renate Wiehager, ed., Sylvie Fleury, Cantz, Osfildern-Ruit 1999.
- JoAnn Wypijewski, *Painting by Numbers: Komar and Melamid's Scientific Guide to Art*, Farrar, Straus, and Giroux, New York 1997.
- Further reading
- Jean Baudrillard, 'Symbolic Exchange and Death', in Selected Writings, ed. Mark Poster, Polity Press, Cambridge 1988.
- Manuel Castells, *The Information Age: Economy, Society and Culture.* Volume 1. *The Rise of the Network Society*, Blackwell, Oxford 1996.

Terry Eagleton, The Illusions of Postmodernism, Blackwell, Oxford 1996. Christopher Norris, What's Wrong with Postmodernism: Critical Theory and the Ends of Philosophy, Harvester Wheatsheaf, Hemel Hempstead 1990 Herbert I. Schiller, Culture Inc.: The Corporate Takeover of Public Expression, Oxford University Press. Oxford 1989.

Alan Sokal and Jean Bricmont, Intellectual Impostures: Postmodern Philosophers' Abuse of Science, Profile Books, London 1998.

Chapter 4: Use and prices of art

References

- Hans Abbing, Why Are Artists Poor? The Exceptional Economy of the Arts, Amsterdam University Press, Amsterdam 2002.
- Alexander Alberro, Conceptual Art and the Politics of Publicity, The MIT Press, Cambridge, Mass. 2003.
- Walter Benjamin, *The Arcades Project*, trans. Howard Eiland and Kevin McLaughlin, The Belknap Press of Harvard University Press, Cambridge, Mass. 1999.
- Ernst Bloch, *The Utopian Function of Art and Literature: Selected Essays*, trans. Jack Zipes/Frank Mecklenburg, The MIT Press, Cambridge, Mass. 1988.
- Pierre Bourdieu and Alain Darbel, *The Love of Art: European Art Museums and Their Public*, trans. Caroline Beattie/Nick Merriman, Polity Press, Cambridge 1991.
- Kim Bradley, 'The Deal of the Century', *Art in America*, vol. 85, no. 7, July 1997, pp. 48–55, 105–6.
- Robert Brenner, The Boom and the Bubble: The US in the Global Economy, Verso, London 2001.
- Benjamin Buchloh, 'Critical Reflections', *Artforum*, vol. 35, no. 5, January 1997, pp. 68–9, 102.
- Timothy Cone, 'Regulating the Art Market', Arts Magazine, vol. 64, no. 7,

- March 1990, pp. 21-2.
- Neil Cummings and Marysia Lewandowska, *The Value of Things*, Birkhäuser, Basel 2000.
- Neil De Marchi and Craufurd D.W. Goodwin, *Economic Engagements with Art*, Duke University Press, Durham, NC 1999.
- Deutsche Guggenheim, Jeff Koons: Easyfun and Ethereal, Berlin 2000.
- Adrian Ellis, 'Museum Boom Will Be Followed by Bust', *The Art Newspaper*, no. 116. July–August 2001. p. 14.
- Coco Fusco, The Bodies that Were not Ours and Other Writings, inIVA/Routledge, London 2001.
- Liam Gillick, Literally No Place: Communes, Bars and Greenrooms, Book Works. London 2002.
- Kassel, Internationale Austellung, *Documenta IX*, Edition Cantz, Stuttgart 1992.
- Naomi Klein, No Logo: Taking Aim at the Brand Bullies, Flamingo, London 2000.
- Niklas Luhmann, *Art as a Social System*, trans. Eva M. Knodt, Stanford University Press, Stanford 2000.
- Cynthia MacMullin, 'The Influence of Bi-Nationalism on the Art and Economy of Contemporary Mexico', in Deichtorhallen Hamburg, Art & Economy, ed. Zdenek Felix/Beate Hentschel/Dirk Luckow, Hatje Cantz, Ostfildern-Ruit 2002.
- Mark W. Rectanus, *Culture Incorporated: Museums, Artists and Corporate Sponsorships*, University of Minnesota Press, Minneapolis 2002.
- Howard Singerman, Art Subjects: Making Artists in the American University, University of California Press, Berkeley 1999.
- Leo Steinberg, Other Criteria: Confrontations with Twentieth-century Art, Oxford University Press, New York 1972.
- Mark Wallinger and Mary Warnock, eds., Art for All? Their Policies and Our

Culture, Peer, London 2000.

Peter Watson, From Manet to Manhattan: The Rise of the Modern Art Market, Hutchinson, London 1992.

Whitechapel Art Gallery, Liam Gillick: The Wood Way, London 2002.

Chin-tao Wu, Privatising Culture: Corporate Art Intervention Since the 1980s, Verso. London 2001.

Further reading

Bank, Bank, Black Dog Publishing, London 2000.

Pierre Bourdieu and Hans Haacke, *Free Exchange*, Polity Press, Cambridge 1995.

Bruno S. Frey, Arts and Economics: Analysis and Cultural Policy, Springer, Berlin 2003.

Rita Hatton and John A. Walker, Supercollector: A Critique of Charles Saatchi, Ellipsis, London 2000.

Eleanor Heartley, 'The Guggenheim's New Clothes', *Art in America*, vol. 89, no. 2, February 2001, pp. 61–3.

Andreas Huyssen, 'Escape from Amnesia: The Museum as Mass Medium', in *Twilight Memories: Marking Time in a Culture of Amnesia*, Routledge, New York 1995.

Kobena Mercer, 'Intermezzo Worlds, Art Journal, vol. 57, no. 4, Winter 1998, pp. 43–6.

Martha Rosler, 'Video: Shedding the Utopian Moment', in Doug Hall and Sally Jo Fifer, eds., *Illuminating Video: An Essential Guide to Video Art*, Aperture/Bay Area Video Coalition, New York 1990.

Julian Stallabrass, Internet Art: The Online Clash of Culture and Commerce, Tate Gallery Publishing, London 2003.

Much detailed information about the economics of the art world can be found in *The Art Newspaper*.

Chapter 5: The rules of art now

References

York 1992

- Alexander Alberro, Conceptual Art and the Politics of Publicity, The MIT Press, Cambridge, Mass. 2003.
- Pierre Bourdieu, The Rules of Art: Genesis and Structure of the Literary Field, Polity Press, Cambridge 1996.
- Arthur C. Danto, After the End of Art: Contemporary Art and the Pale of History, Princeton University Press, Princeton, NJ 1997.
- Diedrich Diedrichsen, 'The Boundaries of Art Criticism: Academicism, Visualism and Fun', in Jürgen Bock, ed., From Work to Text: Dialogues on Practise and Criticism in Contemporary Art, Fundação Centro Cultural de Belém, Lisbon 2002.
- Hal Foster, *Design and Crime (and Other Diatribes)*, Verso, London 2002. Francis Fukuyama, *The End of History and the Last Man*, The Free Press, New
- Renée Green, 'Introductory Notes of a Reader and "A Contemporary Moment", in Jürgen Bock, ed., From Work to Text: Dialogues on Practise and Criticism in Contemporary Art, Fundação Centro Cultural de Belém, Lisbon 2002.
- Michael Hardt and Antonio Negri, *Empire*, Harvard University Press, Cambridge, Mass. 2000.
- Dave Hickey, *Air Guitar: Essays on Art and Democracy*, Art issues.Press, Los Angeles, 1997.
- Dave Hickey (curator), Beau Monde: Toward a Redeemed Cosmopolitanism, Site Santa Fe's Fourth International Biennial 2002.
- David Hume, 'An Inquiry Concerning Human Understanding', in *On Human Nature and the Understanding*, ed. Antony Flew, Collier, London 1962.
- Jean-François Lyotard, The Postmodern Condition: A Report on Knowledge,

trans. Geoff Bennington and Brian Massumi, University of Minnesota Press, Minneapolis 1984.

Thomas McEvilley, Art and Otherness: Crisis in Cultural Identity, Documentext/McPherson 1992.

Museum of Modern Art, 'Primitivism' in Twentieth Century Art: Affinity of the Tribal and the Modern, New York 1984.

Meyer Schapiro, 'The Sculptures of Souillac', in *Medieval Studies in Memory of A. Kingsley Porter*, ed. Wilhelm R. W. Koehler, Harvard University Press, Cambridge, Mass. 1939.

Robert Venturi, Denise Scott Brown, and Steven Izenour, *Learning from Las Vegas: The Forgotten Symbolism of Architectural Form*, The MIT Press, Cambridge, Mass. 1977.

Paul Virilio, Art and Fear, trans. Julie Rose, Continuum, London 2003.

Further reading

Bill Beckley and David Schapiro, eds., Uncontrollable Beauty: Towards a New Aesthetics, Allworth Press, New York 1998.

Suzanne Perling Hudson, 'Beauty and the Status of Contemporary Criticism', *October*, no. 104, Spring 2003, pp. 115–30.

Gene Ray, 'Mirroring Evil: Auschwitz, Art and the "War on Terror", Third Text, vol. 17, issue 2, 2003, 113–25.

Chapter 6: Contradictions

References

Theodor W. Adorno, *Aesthetic Theory*, trans. Robert Hullot-Kentor, University of Minnesota Press, Minneapolis 1997.

Matthew Arnatt and Matthew Collings, *Documenta 11*, Artswords Press, London 2002.

Rachel Baker: http://www.irational.org/tm/archived/tesco/front2.html

Walter Benjamin, 'The Author as Producer', 1934, in Selected Writings. Volume 2. 1927–1934, Michael W. Jennings, Howard Eiland, and Gary Smith, eds., The Belknap Press of Harvard University Press, Cambridge, Mass. 1999.

Pierre Bourdieu, The Rules of Art: Genesis and Structure of the Literary Field, Polity Press, Cambridge 1996.

Nicolas Bourriaud, *Relational Aesthetics*, trans. Simon Pleasance/Fronza Woods. Les Presses du réel. Dijon 2002.

Benjamin H.D. Buchloh, Neo-Avantgarde and Culture Industry: Essays on European and American Art from 1955 to 1975, October, Cambridge, Mass. 2000.

Alexander Cockburn, Jeffrey St. Clair, and Allan Sekula, Five Days that Shook the World: Seattle and Beyond, Verso, London 2000.

etoy, Digital Hijack: http://146.228.204.72:8080/

eToys dispute: http://www.toywar.com/

Paul Garrin, Name.Space: http://name.space.xs2.net/

Serge Guilbaut, How New York Stole the Idea of Modern Art: Abstract Expressionism, Freedom, and the Cold War, trans. Arthur Goldhammer, University of Chicago Press, Chicago 1983.

Michael Hardt and Antonio Negri, *Empire*, Harvard University Press, Cambridge, Mass. 2000.

Karl Marx and Friedrich Engels, The German Ideology, Prometheus Books, Amherst, NY 1998.

Leo Steinberg, Other Criteria: Confrontations with Twentieth-century Art, Oxford University Press, New York 1972.

Paul Virilio, *Art and Fear*, trans. Julie Rose, Continuum, London 2003. *Further reading*

Emma Bircham, and John Charlton, eds., *Anti-Capitalism: A Guide to the Movement*, Bookmarks Publications, London 2001.

- Notes from Nowhere, ed., We Are Everywhere: The Irresistible Rise of Global Anticapitalism. Verso. London 2003.
- Okwui Enwezor et al., eds., Democracy Unrealized: Documenta11_Platform1, Hatje Cantz, Ostfildern-Ruit 2002.
- Okwui Enwezor et al., eds., Experiments with Truth: Documenta11_Platform2, Hatie Cantz. Ostfildern-Ruit 2002.
- Okwui Enwezor et al., eds., Créolité and Creolization: Documenta 11_Platform 3, Hatje Cantz, Ostfildern-Ruit 2003.
- Armando Silva et al., eds., Urban Imaginaries from Latin America: Documenta 11_Platform4, Hatje Cantz, Ostfildern-Ruit 2003.
- Julian Stallabrass, Internet Art: The Online Clash between Culture and Commerce, Tate Publishing, London 2003.
- Adam Wishart, and Regula Bochsler, Leaving Reality Behind: The Battle for the Soul of the Internet, Fourth Estate, London 2002.

Abbing, Hans 112-13, 128	autonomy of 114-24, 200-1
Abe, Stanley K. 66	globalization 11, 13-15, 19
Absolut (vodka company) 131	homogenization of 42-3, 150-75,
academic art writing 162-3	187
Adorno, Theodor 81, 99, 201	investment in 104,111
advertisements 98, 144, 145, 151	knowability of 9-10, 150-1
contemporary art and 7, 130-1,	recession 105-12
158, 160	secondary market 101,126
displacement 158, 160	supply and demand 101-4, 169
postmodernism 78	Art of the Motorcycle, The
propaganda art 60	(Guggenheim) 144
aesthetics 75,82,176–83	Art on the Net 196
Africa 168, 189–90, 191	Artforum (journal) 164
Afrika, Sergei Bugaev 48–9	artists:
Mir: Made in the XXth Century 46,	academic training 116-17
177	anti-social 51–2
Air Guitar (Hickey) 168	biennales and 34,38-41
Alberro, Alexander 127, 154	black British 12
Alÿs, Francis 108, 109, 110	brand recognition 145
American Century, The (Whitney	celebrity 14-15, 80, 136, 145, 150
Museum of American Art) 140	communist 55-8,63-8
Amoris, Gabinete Ordo 158	and corporations 131-2
Anglican Cathedral, Liverpool 29-31	freedom of 3
anti-capitalist movements 181,197	German 99
Araeen, Rasheed 12	Internet 125
architecture 143,144	poverty of 113
Argentina 107	youthfulness 84
Armani, Giorgio 144	Asia 168
Arnatt, Matthew, and Collings,	auction houses 101, 104, 125-7
Matthew 189–90	avant-garde 9,58-9,62,66,67,100,
ARS 95 (international art festival,	151, 164, 200
Helsinki) 42–3	Azcárraga, Emilio 108, 109
Art and Language group 129, 154	
art collectors see collectors	B & Q (DIY company) 145
art history 170	Bäckström, Miriam 53
art institutions 116, 134	Baffler, The (US magazine) 78
art market 5, 114, 128-9	Baker, Rachel 194

Brener, Alexander 55-6 Bank (London-based collective) 129 Brenner, Robert, The Boon and the Barbara Gladstone Gallery, New York 67 Bubble 111 Barney, Matthew 154 Bruguera, Tania 62 Barrie, Dennis 15-16 Buchloh, Benjamin 20, 88, 149, 195 Baudrillard, Jean 82 Budney, Jen 40 Beau Monde: Toward a Redeemed Bulgakov, Mikhail 50 Cosmopolitanism (Site Santa Fe, bureaucracy 119,121 2001) 171-3 Burroughs, William 78 beauty in contemporary art 17, Busan Biennale, South Korea 34 107, 163-75 Becher, Bernd and Hilla 94, 95 Calderon, Miguel 108 Becker, Carol 42 capitalism 2, 7-8, 10, 175, 191, 194 Becker, Howard 142 see also neoliberalism Beecroft, Vanessa 84, 89, 177 Castro, Fidel 60 Benjamin, Walter 121-2, 191 Cattelan, Maurizio, Stadium 158 Berlin Biennale 34 celebrity 14-15, 136, 145, 148, 150 Bhabha, Homi 35 censorship 20, 38, 59, 68 biennales 33-44, 64, 67, 132, 171-3, Cervantes, Miguel de 181 Chapman, Dinos and Jake 35 Bijl, Guillaume 82 Chicago Museum of Contemporary Biklo, Mike 92 Art 141 Bilbao 141, 142-3 Chin, Mel, Night Rap 17, 18 China 56-8, 59-60, 62-4, 98 Black Male exhibition (Whitney Museum, 1994) 17 Chinese artists 55-6, 63-7 Blazwick, Iwona 123 Chomsky, Noam 59 Bloch, Ernst 118 Cincinnati Contemporary Arts Center Bonami, Francesco 132 15 - 16Bond, Anthony 30, 32 Clinton, Bill 16, 19 Bourdieu, Pierre 8-9, 115, 146, 147, Closky, Claude 80 174, 184, 200 Coagula (art magazine) 68,70 Bourriaud, Nicolas 176, 177-9, 182 Cockburn, Alexander and St.Clair, BP (British Petroleum) 134 Jeffrey 197 collectors 3, 4, 101, 104-5, 126, 127-8 Bradley, Kim 143 Colombia 29 Brancusi, Constantin 68 brand image 79-80, 130, 144-8 Columbus Monument, Lisbon 197 Brecht, Bertolt 86 commodification 76,80-1

communication 114,117,118	DAK'ART, Senegal 34
communism 10-11,50,166	d'Amato, Alphonse 15
communist countries 56-72	Danto, Arthur 163, 164-6, 173, 175
conceptualism 152, 154-5	David, Catherine 188
Cone, Timothy 126	Davis, Douglas 16
constructivism 51,52-3,62,195	Day, Corinne 83
consumerism 57,60,67,73-99,130,	De Marchi, Neil 103
147, 195–6	dealers 3, 101, 103-4, 105, 125, 126,
copyright laws 194, 195	154
corporate collectors 127-8	decadence 161-2
corporate culture 78–9	deindustrialization 99, 130
corporate propaganda 98	Delgado, Angel 58–9
corporate sponsorship 128, 134–7,	democracy 169, 178-9, 181-2, 189,
140, 144	195, 196, 199
and biennales 33	deregulation 51,73
Enron 112	Derrida, Jacques 6
installation art 27	Diedrichsen, Diedrich 83, 171
museums 14	digital art 155, 156, 192, 194-6
reasons for 129-32, 136-7, 147-9,	digital photography 184
183	digital technology 26, 79, 161
corruption 23, 24, 106, 109, 111, 112	Dijkstra, Rieneke 84
cosmopolitanism 5, 43, 44, 171-2	Documentas 134,188-9
Courbet, Gustave 9	dot.com bubble 109,111
criticism 3, 17, 19, 68, 163–75, 189	drama 102
Cuba 33, 37, 40-1, 58-9, 62-3, 158	Duchamp, Marcel 88
Cuban artists 67–8	Düsseldorf Kunstakademie 94
Cultural Center for Contemporary	
Art, Mexico City 108	economic(s):
Cummings, Neil and Lewandowska,	growth 107-9,142
Marysia, The Value of Things 131	postmodernism and 174
curators 3,190-1	recession 23-4, 51, 55, 76, 94, 142,
biennales 33, 34, 38, 39, 41	176
censorship of 20	regional crises 107–8
communication with the public	Russian 43–4 see also
118	consumerism
obscenity laws 15–16	education 115-16, 134, 170
	Eliasson, Olafur 112

elitism 12, 163, 187, 192	free trade 2, 4, 6-7, 12-13, 76-7,
Elliott, David 52	129-30, 139, 161, 169
Ellis, Adrian 141	freedom of art 2-4,6-7,199-201
Emin, Tracey 145	freedom of speech 194
Empire (Hardt, M. and Negri, A.) 76-7,	Friberg, Maria 53
174, 187, 194	Frieze (art magazine) 68
Engels, Friedrich 166, 176	Frow, John 80
Enron 109,112	Fukuyama, Francis, The End of History
environment art see installation art	and the Last Man 165,175
Enwezor, Okwui 38	funding for the arts see corporate
Espacio Aglutinador (The Gathering	sponsorship; state-funded art
Space) 62	Fusco, Coco 21, 40, 68, 70, 108
etoy, Digital Hijack 192, 193, 194	
eToys 196	Galassi, Peter 96
Evans, Cerith Wyn 155	Galeano, Eduardo 30
exchange-values 88, 90, 92, 94	Garrin, Paul 195
2	Gauguin, Paul 54
fan literature 171	gay sexuality 16,54
fashion 15, 83-9, 103, 128-9, 131-2,	Geerlinks, Margi 184
144	Gehry, Frank 143
feminism 11,150	genetic manipulation 183-4
Figueroa, Eugenio Valdés 62	Germany 5, 10, 76, 99, 111, 139-40
film 2,49,93,102	gilding 82, 155
financial sectors 75, 104	Gillick, Liam 118-23, 149, 177
fine art 4, 32, 102, 113, 149	Giorgio Armani (Guggenheim, 2000)
Finland 42–3	144
Fisher, Jean 35	globalization 2, 5, 11, 13-15, 19, 26-7,
Five Days that Shook the World	55, 70, 174, 175, 191
(Sekula) 197	Golden, Thelma 17
Flash Art magazine 118	Gormley, Antony 154
Flaubert, Gustave 9, 200	Greece 20
Fleury, Sylvie 81-2, 89, 155	Green, René 173
Floodnet 195	Greenberg, Clement 151, 166, 167
Foster, Hal:	Gu Wenda 55,63
Design and Crime 165	Guevara, Che 179, 181
The Return of the Real 44	Guggenheim museums 141, 142–3
France 4, 5, 140	Guilbaut, Serge 186

Gursky, Andreas 90, 94, 95, 96, 99 Index work (Lisson Gallery, 2002) 154 insider trading 126-7 Haacke, Hans 132, 136 installation art 24-7, 46, 48-9 Haaning, Jens 176 committed art audience for 144 Hall, Stuart 35 ready-made objects 82, 155, 158 Hanrou, Hou 36, 39 video 25, 26, 46, 48, 124, 155 Hardt, Michael and Negri, Antonio, Xu Bing 64,65,66 Intel 140 Empire 76, 174, 187, 194 Haring, Keith 131 interest rates 111 Harvey, Marcus, Myra 188 Internet art 124-5, 152, 192, 194-6 Havana Biennale 33, 37, 40-1, 67 Interpol exhibition (Stockholm, 1996) Hedlund, Maria 53 Hegel, Georg Wilhelm Friedrich 151, investments 104, 111, 126-7 Istanbul Biennale 37 Hickey, Dave 163, 164, 168-73 Jameson, Fredric 71,77 high-tech industries 24, 109 Japan 23, 76, 105-6, 111, 112 Hirst, Damien 35, 112, 129, 133 Jarr, Alfredo, One Million Finnish history 165-7, 170, 174 Passports 42-3 Höfer, Candida 94 Johannesburg Biennale 34, 38-40 Jones, Sarah 84 homophobia 16 Honert, Martin 98 Houston Museum of Fine Arts 141 Kac. Eduardo 184, 185 Hughes, Robert 17, 163 Kant, Immanuel 166 Hugo Boss 83 Kapoor, Anish 154 humanism 122-3 Kcho 63.64.67-8.69 Hume, Lest 160-1 Keifer, Anselm 105 Kellev, Mike 98 iconoclasm 188 Klein, Naomi, No Logo 79, 130 identity politics 20-1, 54, 70, 76, 150 Kolding, Jakob 52–3 If One Thing Matters, Everything Komar, Vitaly 91 Matters exhibition, Tate Britain Koons, Jeff 102-3, 129 86-7 Kramer, Hilton 163 Ikea 53 Krens, Thomas 143 Kulik, Oleg, Dog 49-50, 56 IMF (International Monetary Fund) Kwangju Biennale, South Korea 12, 13 33-4.67 immigration 39,42-3 imperialism 175, 176

1.00.0	00.5
La DS (Orozco, 1993) 158	93–5
Landers, Sean 85	installation art and 25–6
Las Vegas 142, 168	realism and 27
Léger, Fernand 73, 75	'spectacular' 93
Levinthal, David 131	United States and 4
Lewis, Wyndham 190	Mayakovsky, Vladimir 88
Li Xianting 62	media art 39, 40, 41, 90, 150
Libera, Zbigniev, <i>Lego</i> (1996) 160	Melamid, Alexander 91
Literally No Place (Gillick) 119, 121,	Melgaard, Bjarne 54
122	Mercosur Biennale, Brazil 34
literature 4, 102, 171	Merewether, Charles 30
Littman, Robert 108	Metropolitan Museum of Art, New
Liverpool Biennale of Contemporary	York 96
Art (1999) 30-3	Mexico 107, 108-9
Los Angeles County Museum of Art	Microsoft 195
142	middle class 7,40,130
Los Carpinteros 63	migration 39,51,70
Louis Vuitton 131–2	Mikhailov, Boris 44–7, 50
Luhmann, Niklas 114–15	Minglu, Gao 57, 66–7
Lyotard, Jean-François 174	Mirroring Evil, 2002 (Jewish Museum,
	New York) 160
McEvilley, Thomas 38, 163, 164,	Mitnick, Kevin 194
166-7, 173	modernism 53, 54, 68, 73, 75, 95, 164,
MacMullin, Cynthia 108	166–7
McNeill, David 55	modernization 124–9
Madonna 148	money laundering 106
magazines 83, 85, 86, 117-18, 136	Mori, Mariko 98
Magiciens de la Terre 11,12	Mosquera, Gerardo 39, 58
Mao Zedong 58,60	multiculturalism 11-12, 21, 42, 175
Mapplethorpe, Robert 15-16	Muniz,Vik 31,131
Marcos, Subcommandante 181	Murakami, Takeshi 74, 129, 131–2
Martinez, Rosa 34	museums
Marx, Karl 7-8, 88, 92, 96, 98, 166, 176	branding 144-6
Marxism 192	commercialization of 14, 27,
Mason, Raymond, Forward 188	144–5
mass culture 59, 148, 150, 170	expansion programmes 140-4
art and 2-3, 5-6, 14, 26, 73, 77-8,	information availability 146-7

installation art 24–7	Other Story, The (Hayward Gallery,
visitors study 115-16	1989) 12
music 2, 3, 101, 102, 170-1	outsourcing 79,130
	Owada (art band) 3
NAFTA (North American Free Trade	Owenzor, Okwui 189
Agreement) 108	
Name.Space 195	paintings 25, 150
Nation, The (magazine) 163	Aftermath series 31–2
NEA (National Endowment for the	Chinese 63-4
Arts) 16, 138, 140	feedback on 91
Negri, Antonio 76, 174, 187, 194	history 95
neoliberalism 2, 12–13, 42, 111, 130,	and photography 95,96
186–7	saleability of 107
criticism of 188–90	Paris Fair (1924) 73
in Scandinavia 51-2	Parreno, Philippe 177
service sector 75-6	Patriotic Stories (video) 109
technological changes and 79	patronage 113-14, 192
Neto, Ernesto 31	Perfect Moment, The (Cincinnati
Netscape 194	Contemporary Arts Center,
New York 10, 19–20, 70, 128, 134–5	1990) 15–16
New York Museum of Modern Art	performance art 15, 49-50, 107, 176
67, 96, 164	Peyton, Elizabeth 85
Nike 78,135	Pfeiffer, Paul, The Long Count 155, 156
Ninth Chinese National Art Exhibition	Philip Morris (tobacco company)
(Hong Kong, 2002) 63-4	135, 137
, , , , , , , , , , , , , , , , , , , ,	photography 15
obscene artworks 15-16, 20	Aftermath series 31–2
October journal 118	Boris Mikhailov 44-7,50
Ofili, Chris, Holy Virgin Mary 188	digital 184
Open Source (free software	fashion 83, 128-9
movement) 195	large-scale colour 93-5, 124
organized crime 106	obscene 15-16
Organizing Freedom: Nordic Art of the	reproducible 101, 102
'90s exhibition 52	Scandinavian 53
Orozco, Gabriel 108, 158	Seattle anti-capitalist
La DS 159	demonstrations 197, 199
Ortega Damián 158	technological innovation and 124

youthfulness 84-7

Pivi, Paola 155, 157 Ruff, Thomas 94, 95-6, 97 Poland 20 Ruscha, Ed 131 political activism 188-95, 195-7, 199 Russia 43-50.62 political art 29, 107 Russian artists 55-6 politics 15-20, 36-9, 194-5 Russian constructivism 62, 195 Pompidou Centre, Paris 11 Pop Art 58, 60, 67, 151 Saar, Betye 23 postmodernism 9, 11, 62, 73, 75, Saatchi, Charles 126 76-9, 81, 82, 99, 166-7, 174 Salcedo, Doris 29, 30-1, 35 Prague Biennale 34 Sander, August 94, 95 prices 103-4, 109, 112, 126-7 São Paulo 31-2,33 'Primitivism' in Twentieth Century Art Sassoon, Donald 4 (New York Museum of Modern Scandinavia 50-1 Art, 1984) 164 Schapiro, Meyer 161 privatization 27, 73, 76, 79, 132, 134, Schiller, Dan, Digital Capitalism 79 Schjeldahl, Peter 17 production, and consumption 98-9 Schnabel, Julian 105 public art 188 Scott, Giles Gilbert 29 sculpture 25, 29, 30-1, 67-8, 150 racism 16-17,38 Sekula, Allan 196-8 radicalism 92-3, 176 Selfridges (department store) 131, Rauschenberg, Robert 184 ready-made objects 82, 155, 158 Sensation exhibition 188 Reagan, Ronald 134 September 11th terrorist attacks realism 27, 44-9, 87, 174 (2001) 109, 175 Rectanus, Mark 132, 135, 137, 140 Serrano, Andres, Piss Christ 15 Reemstma (German tobacco Shanghai Biennale 34 company) 134 Sharjah Biennale, UAE 33 Rehberger, Tobias, Seven Ends of the Shopping exhibition, Tate Liverpool World 152, 153 Reiss, Julie H. 24 Sierra, Santiago 41, 45 Richman, Jonathan, Government Singerman, Howard 116-17, 160

Royal Society for the Arts 145

Site Santa Fe Biennale (2001) 171-3

slavery 21

Smith, Roberta 24

social class 7, 21, 40, 130

Center 2

Rosenberg, Justin 13

Rosler, Martha 21,77

rock music 170-1

social degradation 44-7 Thatcher, Margaret 134 social democracy 51,53-4,76 Third Text (journal) 35 social inclusion 147-8, 177-8, Third World 12-13, 35, 40 Tiananmen Square massacre (1989) 177 - 83social mobility 137 57,66 Tillmans, Wolfgang 85-7 Sontag, Susan 89 South Africa 34, 38-40 Tiravanija, Rirkrit 177 Southeast Asia 107 tobacco companies 134-5 'spectacular' art 26, 27, 93-6, 136, Toirac, José Angel 60, 61 152, 154, 177 tourism 32, 36, 143 tovs 98, 196 sponsorship 14, 27, 33, 112, 128, 130, 134-7, 140, 141-2, 144 Trace exhibition (Liverpool 1999) 30 - 3Stalbaum, Brett 195 Starr, Georgina 85, 98 Trade Routes: History and Geography (Johannesburg Biennale, 1998) state, uses of art by the 118, 129-30, 38-9 137-8, 147-9, 182-3 Turk, Gavin, The Che Gavara Story 179, state-funded art 10, 15-20, 27, 33, 36, 51, 137-9, 169 180.181-2 Turner Prize 85, 148 status 101, 113-14, 116, 128-9, 148 Steinberg, Leo 100, 184 Stiglitz, Joseph 13 United Kingdom: stock markets 5, 24, 142 art privatization 132,134 Struth, Thomas 94, 95, 96 black and Asian artists 12 fine art student numbers 113 students 113, 116, 160 supply and demand 101-4, 169 government arts promotion 138 production of literature 4 share of global art sales 5 Tate Britain 85, 86-7, 134, 144-5, 148 United States: Tate Liverpool 31, 32, 82 Tate Modern 141, 145 art privatization 134 borrowing 112 tax evasion 23, 106 corporate collecting 128 Taylor-Wood, Sam 145, 162 economic growth 107-8 technological innovation 26, 79, 124, 187, 192 global dominance 186 telecommunications 79 mass-market culture 4 political art 107 television 26, 93, 108, 109 state-funded arts 15-20, 138, 140 Teller, Jürgen 83 Tesco 82, 194 writing on art 163-75

universities 113, 116, 168-9

Warhol Look, The (Barbican Gallery, urban photography 95-6,99 1998) 131 utopianism 51, 78, 119, 121-2, 166-7, Watson, Peter 104, 106 178-9, 181-2 We Are All Normal (and We Want Our Freedom) (artists' writing van der Rohe, Mies 95 collection) 51-2 van Lamsweerde, Inez 184 wealth 141 Venice Biennale 132 welfare state, Scandinavian 51, 53, Venturi, Robert, Learning from Las 54-5 Vegas 173 Whitechapel Gallery, The Wood Way video art 3,41,90,93 exhibition 118-19 installations 25, 26, 46, 48, 124, Whitney Museum of American Art 17,140 Martha Rosler on 77 World Bank 12, 13, 197 reproducible 101, 102 Wrange, Måns, The Average Citizen technological innovation 124 project 54-5 viewers of art 3-4, 184, 186 Wu, Chin-tao 127, 128, 132, 134-5 art-tourists 32-3, 39, 40, 41 education and 115-16, 134, 170 Xu Bing, A Book from the Sky 63, 64, misreadings by 66-7 65,66 museum accessibility 146-7 site-specific installation art 26 Yokohama Triennial 34 socially disadvantaged 137 youth culture 15 Western 62-3, 66-7, 70 youthfulness 84-8, 136, 179 Viola, Bill 3, 85, 112, 154 Virilio, Paul, Art and Fear lectures 161, Zapatistas 181 176-7, 183-4 Zheng Yi 64 Waiting for Tear Gas (Sekula) 197

Walker, Kara 21-3

Art for All 138 Wang Guangyi 57,60 Wang Hongjian 63 Wang Jin 67

163 - 4

Wallinger, Mark and Warnock, Mary

Warhol, Andy 88-9, 92, 129, 131,

Picture acknowledgements

The publishers would like to thank the artists, galleries and organisations who have kindly given permission to reproduce the illustrations listed below.

Black and White

- 1. Mel Chin: Night Rap, 1994. Mixed media, 14 x 61 x 4.6 cm. © the artist.
- 2. Kara Walker: Camptown Ladies, 1998. Cut paper and adhesive on wall, overall size 264.6 x 1969.8 cm. © the artist. Courtesy of Brent Sikkema, New York.
- 3. Santiago Sierra: 160 cm line tattooed on 4 people. El Gallo Arte Contemporáneo, Salamanca, Spain, December 2000. Four prostitutes addicted to heroin were hired for the price of a shot of heroin to give their consent to be tattooed. Normally they charge 2,000 or 3,000 pesetas, between \$15 and \$17, for fellatio, while the price of a shot of heroin is around 12,000 pesetas, about \$67'. © the artist. Courtesy of Lisson Gallery, London.
- 4. Boris Mikhailov: *At Dusk* series, 1993. Black and white photograph, blue toned, 12 x 29 cm. © the artist.
- Sergei Bugaev Afrika: MIR, Made in the Twentieth Century, 1999-2000. Mixed media installation, dimensions variable. Installation at the Russian Federation Pavilion, 48th Venice Biennale, 1999. © the artist. Courtesy of I-20 Gallery, New York.
- José Angel Toirac: Obsession, from the series 'Tiempos Nuevos', 1996. Oil on canvas, 90 x 60 cm. © the artist, courtesy of Fran Magee/Medaid, Austin, TX.
- 7. Xu Bing: A Book from the Sky, 1987-91. Mixed media installation, dimensions variable. © the artist.
- 8. Kcho: Speaking of the Obvious was Never a Pleasure for Us, 1997. Mixed media. Installation at the Israel Museum, Jerusalem. © the artist.
- 9. Takashi Murakami: Hiropon, 1997. Oil paint, acrylic, fibreglass and iron. 223.5 x 104 x 122 cm. Produced by Takashi Murakami. 1/1 master model made by Toru Saegusa (Shadow Moon). Courtesy © 1997 Takashi Murakami/Kaikai Kiki Co., Ltd. All Rights Reserved. Courtesy of Tomio Koyama Gallery, Blum and Poe/photo Joshua White.
- 10. Thomas Ruff: h.e.k.04, 2000. C-print, 185 x 270 cm. © DACS 2004. Courtesy the artist
- Francis Alÿs: Zocalo. 20 May 1999, 1999. Single screen DVD projection with soundtrack. Variable dimensions ALYS990003. © the artist. Courtesy of Lisson Gallery, London.
- 12. Liam Gillick: Renovation Proposal for Rooseum, Malmo, 2000. Digital image.

 © the artist.

Picture acknowledgements

- 13. Damien Hirst: Absolut Hirst, 1998. By permission of V&S Vin & Sprit AB (publ). Absolut Country of Sweden Vodka and logo. Absolut bottle design, and Absolut calligraphy are trademarks owned by V&S Vin & Sprit AB (publ). © 2004 V&S Vin & Sprit AB (publ). Courtesy of the artist.
- 14. Tobias Rehberger: Seven Ends of the World, 2003. 222 glass lamps, bulbs, sockets, dimensions variable. Installation view: Venice Biennale, 2003. © the artist. Courtesy of neugerriemschneider. Berlin.
- 15. Paul Pfeiffer: The Long Count (Rumble in the Jungle), 2001. Digital video loop / video installation. © the artist. Courtesy of The Project New York and Los Angeles.
- 16. Paola Pivi: Untitled (Aeroplane), 1999. Aeroplane Fiat G-91, 300 x 1100 x 860 cm.
 © the artist/photo Attilio Maranzano. Courtesy of Galerie Emmanuel Perrotin, Paris.
- 17. Gabriel Orozco: *La DS*, 1993. Altered Citroën DS, 139.7 x 480.06 x 114.3 cm. © the artist. Courtesy of Marian Goodman Gallery, New York.
- 18. Gavin Turk: Che Gavara, 1999. Billboard poster, 304.8 x 1219.2 cm. © the artist. Courtesy of Jay Jopling/White Cube (London).
- 19. Eduardo Kac: *Alba, the Fluorescent Rabbit*, photograph, from the project *GFP Bunny*, 2000. © the artist. Courtesy of Julia Friedman Gallery, Chicago.
- 20. etoy. CORPORATION, TOYWAR site, 1999, digital illustration. Credit: etoy.com.
- 21. Allan Sekula: Waiting for Tear Gas, 1999-2000. Slide projection (81 images) + text © the artist. Courtesy of Christopher Grimes Gallery, Santa Monica, CA.

Colour

- Jeff Koons: Loopy, 1999. Oil on canvas, 274 x 201 cm. © the artist. Courtesy of Sonnabend Gallery, New York.
- 2. Vik Muniz: Aftermath (Angélica), 1998. Cibachrome, 182 x 121 cm, edition of 10 + 5 AP. © the artist. Courtesy of Galeria Fortes Vilaça, São Paulo.
- 3. Wang Guangyi: *Great Capitalism Series: Coca Cola*, 1993. Oil on canvas, 200 x 200 cm. © the artist, courtesy of Kwai Po Collection, Hong Kong.
- Vanessa Beecroft: VB29.243. Video capture. Vanessa Beecroft. VB29, Le Nouveau Musée, Lyon, 1997. VB29.243. vb.jesse. Photograph by Vanessa Beecroft. © 1997 Vanessa Beecroft.
- 5. Andreas Gursky: Times Square, 1997. Chromogenic colour print, 186 x 250.5 cm. ©

Picture acknowledgements

- VG Bild-Kunst, Bonn and DACS, London 2004. Courtesy of Monka Sprüth Galerie, Cologne/Philomene Magers.
- Thomas Struth: Times Square, New York, 2000. C-print, edition of 10, 178.4 x 212 cm.
 the artist. Courtesy of Marian Goodman Gallery, New York.
- 7. Sylvie Fleury: Serie ELA 75/K (Easy. Breezy. Beautiful.), 2000. Goldplated shopping cart (24 Kt + leaf gilding), bar made of plexiglass with different texts, on turning pedestal (mirror and aluminium), 83 x 55 x 96 cm. Courtesy of the artist and Galerie Hauser & Wirth & Presenhuber, Zurich.
- Zbigniew Libera: LEGO Concentration Camp, 1996, one set from a series of LEGO blocks and boxes made by the artist. Dimensions variable. © the artist. Courtesy of Galleri Faurschou, Copenhagen.

The publisher and author apologize for any errors or omissions in the above list. If contacted they will be pleased to rectify these at the earliest opportunity.